DATE DUE

JE 6 '00			
FE 1 9 '01			
0 1 5 '98			
FE 2			

Alphabet at Work

'. . . the letters should be designed by an artist and not an engineer.'
—William Morris, 'The Ideal Book', 19 June 1893.

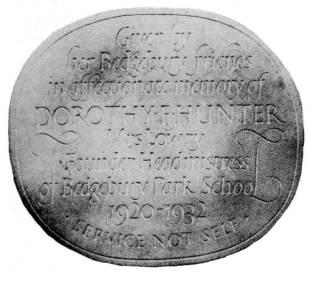 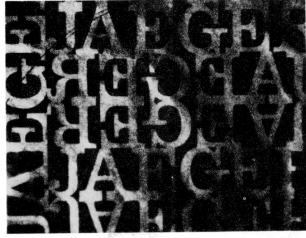

Alphabet at Work

WILLIAM GARDNER

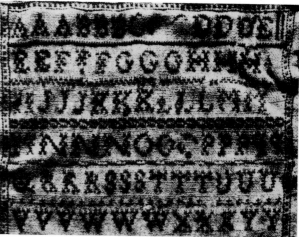

St Martin's Press · New York

First published 1982

St Martin's Press Inc.
175 Fifth Avenue, New York, N.Y. 10010

ISBN 0-312-02139-9

Library of Congress Catalog Card Number 82-050364

Originally published in Great Britain by
A & C Black (Publishers) Ltd.

Designed by Barrie Carr

Text set in Monophoto Gill Sans Light by
Kelmscott Press Limited, and printed in Great Britain
by Fakenham Press Limited, Fakenham, Norfolk

Contents

Foreword

All systems of writing convey meaning. What is unique about our alphabetical method of writing is that it conveys the sounds of words through which precise meaning is conveyed. In this way the alphabet helps to create a bridge of speech between people who can read.

No such bridge is created by pictographic forms of writing such as the Chinese use. Of course their system enables them to communicate their written ideas to one another, but it does not have the additional advantage of incorporating standard written equivalents for the sounds they make in verbal expression. Consequently whatever words are signified to the Chinese by their pictographs can be as widely different as for example the words by which an Englishman and a Frenchman vocalize the meaning of an international sign such as 'no smoking'. (In the French equivalent three words are needed '*défense de fumer*', and the English and French expressions have only two letters of the alphabet in common.)

A further advantage of our alphabet is that it makes it possible for us to pronounce or recognize words that we have never uttered. Indeed we have become so dependent on knowing how words are spelt that if we hear an unfamiliar word or name, our first reaction is usually to ask how it is spelt as this makes it possible for us to check whether we have correctly heard what was spoken.

In our childhood we become familiar with so many different alphabetical combinations that we quickly learn to recognize entire words simply by their shapes (and particularly by the upper part of the letters used). Some school-teachers insist that books used by their infant learners must be printed in types which closely resemble the written forms of letters—for example ɑ and ɡ instead of a and g—because children are first taught to recognize and copy the written forms of the alphabet. It is highly debatable whether this is either helpful or necessary. As children we are all extraordinarily supple in our ability to grasp concepts. For example, though we perceive striking differences of shape in chairs and tables, or trees and flowers, we quickly learn to pick the right words for these objects. During our childhood we also become thoroughly accustomed to accepting wide differences in the shapes of the letters of our alphabet.

By the time we become adults, our experience of differing forms of the alphabet is vast. Yet despite the fact that writing the alphabet is one of the first skills we learn, many of us take these variations for granted. Few of us find the subject as absorbing as philatelists find stamps. Nevertheless it can be the subject of a thoroughly engrossing book, as William Gardner shows in his text and in his fascinating choice of illustrations.

To produce a satisfactory book on the alphabet requires a rare

combination of experience and skill. This work is by a man who describes himself as a 'designer and craftsman in private practice'. In fact his practice has been varied and extensive. He has become internationally recognized as a designer of coins and medals on which his brilliant handling of the alphabet has been a notable feature; but his activities have been wide-ranging. Born in 1914, he studied at the Royal College of Art in London before starting on a career which has included a great deal of teaching and lecturing in various countries, as well as numerous and diverse achievements in design.

I first met him shortly after the war when I commissioned him to make new drawings for the arms of Cambridge University for use in a variety of sizes and weights in books and jobbing work printed at the University Press. What particularly impressed me was his ability to anticipate exactly what would happen when a design was reduced in scale, and the skill with which he managed to make four heraldic leopards look uniformly at ease when they were emblazoned on differently shaped quarters of the University shield. Another example of his gift for bringing balance, order and style into a tricky heraldic problem is shown in page 27. Reproductions will also be found in this book of his work as a calligrapher and lettering artist. In addition he has made designs for stamps and for stained-glass windows.

In two ways this book has gained from his various experiences. Not only have these equipped him with broad knowledge and a gift to communicate it; they have also developed his grasp of how best to encourage creativity in handling the alphabet. His method is not limited to showing good models nor to explaining techniques for executing letters; he also stimulates the imagination by showing a very great variety of alphabetical work; and he dares to imagine that 'on occasions emotion may be encouraged to steal the show'.

A particularly lively chapter in this book is called 'Alphabet at Play'. Anything that has to perform such a universal role in our lives as the alphabet must serve a multiplicity of moods as well as purposes. Ingenuity and invention coupled with zest and humour can be vitally important for some alphabetical purposes; for others, far more important requirements may be discipline and consistency, self-effacement and conformity to tradition. Perhaps the most fascinating aspect of the alphabet is that it can never be entirely devoid of personality, whatever restraints are imposed by conventions. The expert can recognize the hand that cut letters in stone or designed them as a typeface, just as readily as a handwriting expert can distinguish between documents written by two different people. Furthermore the way letters are formed can indicate the country where the writer was taught. Different nations have their own individual ways of writing the same alphabet. And almost imperceptibly the style of hand-

writing, letter-cutting or type design changes from one generation to another. So the manner in which an alphabet is rendered also provides evidence of its age.

Perhaps it is because we all learn to write while we are very young (and while most of us are still also naturally inclined to draw) that so few of us pay much attention to the alphabet later in our lives. Yet it is precisely because we are all so closely familiar with its shapes that this book should interest a public far wider than the few *literati* who are also amateur or professional letterers. Moreover the professionals need an informed public with a discerning taste if they are to produce work of the highest quality. During our lives we all have some occasions when we have to order printing or commission a piece of lettering. Ignorance or prejudice may easily prevent good work from being done with our alphabet. Prejudice may be the more serious hazard: more than one printer I know regards clergymen and architects as his most tiresome clients.

I must also admit that a few printers of my acquaintance have little sympathy for the work of calligraphers and letterers—and *vice versa*. On the other hand, those lucky printers whose main concern has been with fine printing have quickly seen that calligraphers and letterers such as Edward Johnston and Eric Gill can add greatly to the beauty of fine books by supplying colourful headings and titles. Furthermore both Johnston and Gill successfully designed typefaces for commercial use (shown on pages 19 and 21), as did their Dutch and American contemporaries Jan van Krimpen and W. A. Dwiggins. When such men turn their attention to type design, they are quite able to accept the stringent discipline imposed by the need to devise letter-forms that will serve in an infinite variety of combinations while creating words, without any variety in the forms of the repeated letters.

William Gardner includes several reproductions where the manner in which the letters of the alphabet has been contrived is far more striking and successful than the clarity of the words they contain. For much displayed lettering this inversion of the priorities that are usually applied to continuous texts is amply justified. Where the act of reading letters of the alphabet is more concentrated and also has to be maintained for longer periods, familiar shapes and a greater degree of order will be more desirable characteristics —but not total order. For as Jean Cocteau once remarked to Charles Peignot: 'The loveliest poem is never more than a mixed-up alphabet.'

John Dreyfus
London, 2 January 1981

Preface

The magnetism of Edward Johnston in the 1930s plunged me, with others of like susceptibility, straight into the deep end of calligraphy and its consequences. Under such enchantment I submitted most willingly to the rule of Mervyn Oliver, my lettering teacher and hard taskmaster, and to a concurrently ruthless drubbing from George Friend, the engraver. Such good fortune, along with the irresistible appeal of Eric Gill's incised Roman letter-form, led me in turn to impose upon my students as severe a discipline as they were able to take.

Nothing works in a vacuum, and as well as continual revisiting of the finest examples of the past, one's wits need the stimulus of discussion. So it is that I am indebted to those who have challenged my personally held views with hard and searching questions concerning traditions and techniques, and would name Ann Hechle, Freda Harmer, and especially Christopher Russell, who has provided invaluable criticism throughout the compilation.

Others have cast further light upon my survey, not least the staffs of the Victoria and Albert Museum, and of the British Museum and British Library. My wife has shared closely the progress of the work, and I pay tribute also to the photographers J. Wood and J. Sierra, to the publisher's editorial and design staff, and to Sybil Weir for her secretarial help.

W.G.
Chequertree, 1980

Acknow-ledgements

The author and publisher would like to thank the following individuals and organizations for their permission to reproduce illustrative material in this book. While every effort has been made to trace the owners of copyright material we would ask anyone who has not been credited correctly in this edition to contact the publishers, who will rectify any omission in future editions of the book. The numbers in brackets refer to the illustrations.

Anglo-Austrian Society (91)

Cecil Bacon (152)

Batsford Ltd (112, 113, front jacket bottom right) from their book *Lettering for Embroidery*, 1971, by Pat Russell

Bedgebury School, Kent (88)

Kenneth Belden (105)

Ernest Benn Ltd (46, 71, 63, 65) from their book *Lettering*, 1965, by Hermann Degering

Blandford Press (17, 144, 145, 147) from their book *Encyclopedia of Typefaces*, 1962

Bodleian Library, Oxford (79) from MS. Canon. Ital. 196, folio 55

BPC Publishing Group (137, 138) from their book *How to be Topp*, 1954, by Ronald Searle

Nicolas van den Branden for Terence Davis (106)

(75) By permission of the British Library

The Central Lettering Record (96, front jacket middle left)

Central School of Art and Design (49, 156)

Cheltenham College Council (28)

City of London (124, front jacket top right)

Clarendon Press, Oxford (29, 30, 36, 37) from their book *Introduction to Greek and Latin Paleography*, 1912, by E. Maunde Thompson

Arnold Cook Ltd (141)

Coventry Cathedral Provost and Chapter (103)

Kevin Cribb (4, front jacket middle top)

(48) By kind permission of *The Daily Telegraph*

Department of Transport (11)

Designer (139, 140)

Dover Publications Inc from their book *Three Classics of Italian Calligraphy* by Oscar Ogg, 1953 (55, 72) and *Special Effects and Topical Alphabets* by Dan Solo, 1978 (131, 132, 133)

Fitzwilliam Museum, Cambridge (43)

The Jaeger Company Ltd (127)

Trustees of the David Jones Estate (122)

Kungliga Biblioteket, Stockholm (31)

The Leathersellers' Company (25, 90, back jacket bottom right)

Lloyds Bank Ltd (130)

(14, 24) By permission of London Transport

Lund Humphries Publishers Ltd (78, 155) from their book *The Visible Word*, 1969, by Herbert Spencer

Dorothy Mahoney (52)

The Monotype Corporation Ltd (15, 16, 18, 19, 76, 82, 83, 84, 85, 143, 146)

John Murray Publishers Ltd (6, 73) from their book *Reynolds Stone Engravings*, 1977

(154) By courtesy of the Trustees, National Gallery, London

Gillian O'Bryen (106, back jacket bottom left)

Oxford University Press (31) from their book *The English Uncial*, 1960, by E. A. Lowe

Performance Cars (149)

Photo-Lettering Inc, New York (99)

Reinhold Publishing Corporation, New York (99) from their book *The Alphabet Thesaurus*, 1960

Royal Horse Guards (26, 27)

Royal Marines (22)

Royal Society of Arts (12)

The example of Italic Book-hand by William Gardner on p. 43 is reproduced from *A Wordsworth Treasury*, 1978, by permission of the publishers, Shepheard-Walwyn

Spratt's Patent Ltd (148)

Stella Standard (73)

D. Stempel A.G. Frankfurt (17, 142)

Stephenson Blake & Co Ltd (68, 69, 77)

R. Twining & Co Ltd (95)

Unilever Ltd (94)

Victoria & Albert Museum, London, Crown Copyright (4, 20, 34, 38, 45, 66, 108, 128)

Acknowledgements

Watson-Guptill Publications Inc, New York from their book *Production for the Graphic Designer*, 1974, by James Craig (back jacket top two pictures) and *Phototypesetting*, 1978, by James Craig (front jacket top left)

John Weiss & Son Ltd (97)

(129) By permission of the Westminster Theatre

Worshipful Company of Goldsmiths (10)

Introduction

The ABC is such a rudimentary experience for most of us that once early school days are over, its use and form are taken for granted. Behind today's letter shapes, however, is a heritage as diverse and fascinating as that of any other art form. The purpose of this book is to show what has been done and why, rather than to demonstrate how. The alphabet's evolution from simple 'pictographs' to the multi-syllabic complications of modern languages is a lengthy one, the preserve of the palaeographer and lexicographer, and would require a study covering millennia rather than centuries. The threads are picked up here at the Roman alphabet – from which most of our present-day alphabets are derived – in the design of its individual letters, and follow something of our extraordinarily diverse use of them since then. Because the applications of the alphabet are virtually limitless, it will not be possible to show all that deserves to be seen; examples have been selected, wherever possible, to illustrate the significant and innovative steps in the development of letter-forms. Of course letters and the words they form can be used to signify audible speech, but here we are concerned only with their visual presentation. We shall savour as many aspects of the alphabet as space permits, in the presentation of letters through the use of chisel, graver, pen and brush, as well as other instruments.

Apart from the publication of books, probably the greatest usage of letters of the alphabet rests with the media – if rests is the word – as magazines, newspapers, advertising. proprietary packaging and labels pour from the studios and printing houses, with almost as many signs, trade and public notices, and facia boards, along with commemorative and industrial utilizations in countless other materials. It is a vast field. At least one English university and one art college have already sponsored a comprehensive collection of hand-lettering styles alone, brought together from everywhere, and the bibliography at the end of this book will indicate where further illustrations of alphabetic applications may be found.

While most of us assimilate hand-written, or printed, or lettered wording with no more thought beyond the message conveyed, there have always been those as much interested in the means itself as with the end. John Ruskin's diary reveals a particularly cold-blooded approach to the collection of illuminated initial letters on vellum: 'spent the day cutting up a missal – hard work.' In 1889–91 William Morris, with more sympathy, pioneered the rethinking of modern printed letter-form. With typographer Emery Walker he returned to the Venetian typefaces of the later fifteenth century, and from Nicolaus Jenson's fount evolved his Golden typeface. In 1891 Morris added a softened, or 'humanized', Gothic face called Troy (1) with the intention of redeeming such alphabets from the usual charge of unreadableness.

Frederico tertio Romanorum imperatore regnante, magnum quoddam ac pene divinum beneficium collatum est universo terrarum orbi a Joanne Gutenbergk Argentinensi novo scribendi genere reperto. Is enim primus artem impressoriam in urbe Argentina invenit. Inde Magunciam veniens eandem fœliciter complevit.

I wold demaunde a question yf I should not displease, How many Knyghtes ben ther now in Englond that have thuse and thexercyse of a Knyghte? That is to wete, that he knoweth his hors & his hors hym, that is to saye, he beynge redy at a poynt to have al thing that longeth to a Knyght; an hors that is according and broken after his hand, his armures and harnoys mete and fytting and so forth, et cetera.

1. Golden (above) and Troy typefaces by William Morris, 1889–91.

A reformation is never an easy task. Edward Johnston, pioneer in the rediscovery of the essential qualities of letter-form, found that twelve lectures were barely enough for his earlier students to cover the characteristics of the Roman alphabets as far as A and B!

Against a more contemporary backdrop, twentieth-century American lettering artist Ben Shahn confesses in his own testimony, *Love and Joy about Letters* (1963),

I fell in love all over again with letters. To make a perfect Roman letter . . . I suppose that I spent months just on the A alone; and then when I felt I was ready to move on to B, the foreman of the shop, my boss and my teacher, would not accept that A, but condemned me to more work and more making of As. As I learned the alphabet, and then many alphabets and many styles of alphabet and ornamentation and embellishment of letters without end, I found here too the wonderful interrelationships, the rhythm of line as letter moves into letter. . . .

For English-speaking peoples, since overriding success has not yet attended any one of the many ingenious attempts to create a new alphabet for worldwide use, the Roman alphabet is retained; though this is by no means to say that an acceptable alternative isn't just around the corner. Such an event would in fact enhance rather than detract from the Roman alphabet's intellectual appeal. In pursuit of these letter-forms which have enjoyed such an impressive survival, a rare book – which may be consulted in the British Library and at the Victoria and Albert Museum – is recommended to those curious enough. Emil Hübner, its author, examined and illustrated the many Roman inscriptions of the Mediterranean and further afield in an exhaustive catalogue published in Berlin in 1885, under the title *Exempla Scripturae Epigraphicae Latinae*. . . . Of the hundreds of examples shown, that incised at the base of the column commemorating the Emperor Trajan at Rome, probably cut in the year A.D. 113, has long been the most admired, having irresistible appeal in its construction, springiness, legibility and fine spatial relationships. It has since been re-examined by Edward M. Catich (1961), and again by James Mosley (1964).

It is arguable that the Trajan inscription, though hardly excelled in beauty and verve, is run very close, letter for letter, by others; by Hübner's example No. 114, for instance, from the theatre at Pompeii, cut c 27 B.C.–A.D. 54. It is beyond dispute, however, that this twilight perfection of the Roman alphabet provided a springboard for the evolution of European calligraphic styles during the chaotic post-Roman era. In the making of records of all kinds, writing fell to the clerics whose pens were of similar shape to the square-ended instruments responsible for contriving the shapes of the letters of the Roman

inscriptions themselves. By the sixteenth century contemporary letter-forms were crystallized in the printing press at the very moment when the so-called 'Gothic' styles were yielding to a rediscovery of the classical Roman letter-forms, and to inherited minuscules as elegant as the capital letters they were to accompany.

In no time at all, alongside the engraver's lettering on copper plates derived from Italianate cursive penmanship of the fifteenth and sixteenth centuries, European printers were multiplying impressions of metal-type letters designed by the lettering artists, who had driven out the professional book-scribes. Nor has there since been a lack of interpreters of letter-form among carvers, casters, gold and silver-smiths, engravers, jewellers, signwriters, embroiderers, weavers, bookbinders, architects, and more recently the graphics and advertising fraternities.

With regard to printing, the age of impression from inked metal letters initiated by Johann Gutenberg in the middle of the fifteenth century, would seem now virtually over, but responsibility in the use of the film which is taking its place could never be greater, nor has the lettering artists' opportunity diminished; far from it. In current lettering exhibitions a less inhibited, yet sensitive attitude is already in evidence. New materials are being used and letters themselves are being woven into knots and garlands and arabesques richly arranged. The words of a message may be present, yet half hidden behind inspired decorative usage. On occasion even a wilful discord may serve to clarify our responses; and random association of letters, too, can produce stimulating optical consequences, totally out of reach of those whose only working dress is a strait-jacket.

There is little chance here to discuss decorative adjuncts to lettering which in the past have been based on geometric forms – such as the abstract decor on early medieval manuscripts – or on the patterns of nature: the floral textual decorations of William Morris, for example. But there is now available a new, virtually unlimited and scarcely tapped source of shapes and patterns revealed through the electron microscope, and of which substantial photographic collections already exist. Craftsmen and lettering artists will certainly come to terms with this fresh stimulus and discipline; and steps in this direction are already, in fact, being taken in America.

We must all acknowledge our debt to Edward Johnston in putting back on the rails the alphabet so sadly abused during much of the nineteenth century, trade printers sharing a large part of the responsibility for the relapse; but we must also acknowledge the vacuum which enabled Johnston's magic to work. In the heritage and spirit of William Morris, and through a personal introduction by Harry Cowlishaw, it was William Lethaby who secured for Johnston in 1899 the significant

new teaching post at the Central School, where the seven students who came to study letter-form with him were to effect the reformation itself. No reformation is possible without awareness that something is wrong and the finding of bearings for a redirection. Edward Johnston achieved both in his time.

It is largely due to Eric Gill (1882–1940) and his assistants that a vigorous tradition in the field of stone-carved letters has survived, notably at Cambridge. And much is owed to MacDonald Gill and his circle for present high standards in signwriting, while the typographic presentation of finely printed books in England has been fundamentally influenced by the lives and work of Morison, Meynell and Stone, among others. Crafts such as needlework and glass-engraving have recently demonstrated a revived sensitivity towards the alphabet, and scribes have begun to extend the normal relationships between letter-form and sight to other senses. Should words become units in some skilful composition, then even a message may find itself transcended by preoccupation with colour, dimension, direction, weight, texture, or speed, as these and other factors become interrelated in ecstatic mood. We have a long way to go in these matters and opportunity is limitless.

The late Stanley Morison, print historian and bibliophile, expressed the view that 'there exists an effective universal consensus upon the principles that should govern the shapes and uses of the Graeco-Roman alphabet in all works addressed to the intelligence of mankind ... the best guarantee against experiment or innovation or irresponsibility. By irresponsibility', he went on, 'is meant any reduction of the authority proper to the style of permanent literature addressed to the intelligence of man in favour of the freedom proper to ephemeral matter addressed to the emotions of man.' This is most compelling, but dare one envisage that on occasions emotion may be encouraged to steal the show? Further still, through emotion and even ephemerality, may not the alphabet at times gain qualities unobtainable through intelligence alone? Like Dylan Thomas's shepherd who made ritual observances to the moon for the protection of his flock, we too might well be damn' fools if any possible advantages remained uninvoked.

All the possibilities aside, one may turn to David Diringer's definition of writing as the reproduction of sounds which come from the mouth or unspoken thoughts which come from the brain, by permanent visual symbols on paper, stone, metal, wood, leather, linen, or some other material. It is time to look closely at the design of the twenty-six letters which comprise our current alphabet, before moving on to their arrangement and something of the work they are made to do for us.

The letters individually

One of the most distinctive characteristics of the Roman inscriptional alphabet is that its letters are not all of uniform width. Of its twenty-six letters (J, K, U, W and Z were generally excluded by the Romans) nearly half are what printers term 'wide set', and over half 'narrow set'. It is essential not to condense C, D, G, H, M, N, O, Q, U, W and Z or to extend A, B, E, F, I, J, K, L, P, R, S, V, X and Y to a common span for the sake of convenience in space calculation; the result would certainly look 'un-Roman'. T does not belong to either category, since within certain limits its horizontal member may vary in length. Obviously **T** or **T** will hardly do, but **T** or **T** are acceptable, and the space on either side of its stem becomes an important consideration, discussed later on.

It will be seen immediately that this alphabet is composed of straight stems (vertical, oblique and horizontal) combined with curved ones – **O** for instance may be thought of as having two curved stems – and that all letters have features in common.

Letter I occurs in at least twelve characters, and curved strokes appear in eleven. Ten letters also have oblique strokes: those descending, as it were, from north-west to south-east being broad and stressed; those angled the other way, with one exception, being somewhat thinner. The distinctive stresses of the alphabet are derived from the way in which the letters were set upon the stone for the carvers to follow. It seems that most Roman lettering artists were right-handed and used a square-ended brush, its edge set at about 30° from horizontal. Consider a zigzag line painted in this way towards the right: ⁄⁄\\/\\/\\/\\. It will at once be clear why **A** has its heavy stem on its right, and why **V** has its heavy stem to the left; likewise **M**'s second and fourth stems, and **W**'s first and third. The square-ended brush held in the right hand dictated the curves also, **C** having its heaviest point below centre and **⊃** its heaviest point above. There is of course no basis for the notion that an **⊘** apparently turned anti-clockwise a few degrees in this way either leans to the left, or has a tendency to roll in that direction. It rests in a state of equilibrium just like a counterpoised wheel. It is important to know about the existence of stress, and to understand that it was originally brought about not by changes of pressure but by direction.

Letters **V**, **O** and I contain all the shapes needed to create the complete alphabet of Roman letters, so if these three are fully understood and properly stressed the rest should follow suit. The Trajan inscription I has a width-to-height ratio of approximately 1:10 units. Its stem is slightly 'waisted' and bears four serifs, or sharpened corners. Ideally its ends are slightly incurved as well, lending an enhanced crispness to these corners. In fact if ends are not so 'dished' they will appear to bulge outwards due to an optical illusion (A), which also affects the

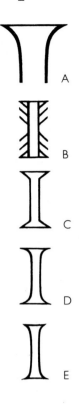

sides of the stem if its outline is parallel. To demonstrate the need for stem outlines to be bent inwards, two vertical and parallel lines are here subjected to a test pattern of obliques which at once result in the illusion of a bulge (B). This is precisely what happens when serifs are added to a parallel-sided stem (C). By curving both sides of the stem inwards very slightly, the illusion of a bulge may be partially defeated (D), but quite a pronounced inward curvature will be needed to counteract the effect of the serifs and produce a model for the stems of a lively and elegant alphabet throughout (E).

All this was done, of course, through the discipline of hand and eye. Da Vinci, Dürer, Jacques Jaugeon, and a considerable number of others felt obliged to attempt some drill for the construction of Roman letters by purely geometric means but, as might be expected, an end-product done with square and compasses alone is little more than geometric 'dead duck'.

Features of the classic Roman inscriptional alphabet are not really attention drawing in themselves. If the trumpet-shaped ends of a letter I with its subtle curvature and crisp serifs are overdone the letter looks 'wedgy': I. A further optical illusion arises where the sharp points of A, M, N, V and W end precisely at the upper or lower letterer's guide line. Owing to the inward curvature of the stems concerned, terminal sharpnesses appear to peter out before reaching the line, the solution being to project such points slightly through the upper or lower guide line to make them appear correctly positioned. These guide lines are solely for the letterer's reference and do not remain in a finished inscription (they have been left on the letters illustrated in the margins to illustrate their function); they are discarded like scaffolding when the work has been completed, to be replaced by the sequences of serifed stems which themselves are in alignment.

The horizontal member of a letter A, if similarly formed with a square-ended brush or pen held right-handed at 30° from the horizontal, will be of a weight about half that of the heavier main stem. Because letter A narrows inside towards the top, the horizontal bar cannot with visual comfort be raised to a position which would close the contained triangular area virtually to nil; this can have the effect of closing the area completely due to the spread of ink in the case of a heavily printed impression upon paper at small scale. Conversely it would produce an unduly droopy appearance to pose the horizontal bar too near the bottom guide line. An optically balanced solution is called for. This letter has also been seen narrowed or widened to extremes, and some kind of restraint would seem necessary. Generally at all places where stems meet, such as at the top of A, they should form an axial hinge, however the top may be constructed: see figures F, G and H, left.

B

C

D

E

In its overall appearance B consists of two Ds placed one above the other. True, the lower form is not entirely D-like, but the analogy holds. The lower one is somewhat the larger, no doubt for stability's sake and to avoid top-heaviness. This goes also for letters E, H, K, R, S, X and Y, which at first sight are all evenly divided between top and bottom. Look at them upside down, however, and the contrivance is revealed.

C is not unlike an O from which about one-fifth has been sliced vertically from its right-hand side, with both truncations carried outside the circle, the upper one being given an emphasis due to the usual stress of a notionally completed O. The left-hand curve behaves precisely as that of O, with its heaviest point below centre.

The form of D may be arrived at by slicing away vertically about one quarter of the width of an O at its left side, and adding the stem of a letter I outwards of that point. Since curves in this alphabet are poised at an axis of some 30° from the vertical, the base of this letter tends to strengthen towards the stem as though to turn itself into an O, and for the same reason there is no such tendency at the top.

The hardest-worked letter in the English language, E has an overall proportion of approximately two squares arranged vertically and consists of an upright stem carrying three horizontal members projecting to the right. In order that its second horizontal should appear truly central it should rest above a central guide line as shown here. The eye finds greater difficulty in assessing true centre from top to bottom than horizontally, and tends to attribute a visual 'lowness' to items truly central. All three horizontal members are of approximately equal length. To gain visual stability, while the 'heel' of the lowest should line up with the other two above, its 'toe' may be encouraged to project somewhat beyond. All three horizontals are serifed and it is of interest in passing that in many nineteenth-century examples inordinately long serifs almost touched, driving the central member back inside the letter where there was room to stretch its own serifs to similar lengths. A helpful check to discover if a Roman E has been well proportioned is to notice if its two inside areas echo D-like shapes. Even this angular letter tends to borrow some characteristic from O with a slight curvature at its lower left-hand internal angle, as the superimposition of an E upon an O would suggest.

F is virtually letter E with its lowest horizontal member removed. But if the lower of its two remaining horizontals were placed above a central guide line as for E, a 'south-easterly' void would be felt. It should be aligned at a position truly central; even where F and E are adjacent, the difference in their second horizontals is hard to detect.

G

H

IJ

K

L

G may be regarded as a development of the letter C, its short, straight stem being added in its south-eastern corner at a point some three-quarters of the width of a notional O, in this respect recalling a letter D reversed. It would be tidy, perhaps, if the stem rose exactly to mid-height, but even in the Trajan inscription this may be thought of as slightly aggressive or 'lantern jawed'. Something less than mid-height may be preferable, but not of course so little as to call to mind a 'weak chin'. An optically balanced height of say two-fifths of a letter I may be found acceptable. A base which curves all the way into the stem is likely to make the letter look unsteady but a strong angle little more than 90° between this short stem and the end of the base will ensure stability.

Like letter T, H is open to some adjustments in its overall width which may vary from between four units wide and five high, as here, to virtually square. Its two stems are identical with the letter I, while its horizontal member should be placed as for E, resting above centre to appear central. The distance between the two stems of the letter will tend to set the pace of a rhythmical progression of stems throughout a sequence of letters, and should be given attention. This point will be returned to when the spacing of letters is discussed.

Letter I has already been analysed. In Roman inscriptions it commonly did duty for what we now know as J, itself largely unused by the Romans (TRAIAN in the inscription cited) while K is a letter which was similarly ignored in favour of hard C.

K looks best when the pointed junction of its two right-hand members touches the main stem very slightly above true centre. The word 'touch' is important since physical difficulties, even a kind of knot, may arise when this junction is allowed to take place within the main stem itself. It may even prove advantageous to avoid actual contact with the main stem—a close gesture towards it sufficing. In penmanship the oblique tail of this letter is naturally its heaviest stroke, and on the whole it is best without an inward-turning serif which tends to pro-duce the appearance of a suction pad adhering to the bottom guide line, when its toe should rather be 'fancy-free'. Nothing could look more disjointed, however, than the very frequent **K** 'on crutches'.

L presents little difficulty in its construction, its horizontal member following the lowest one of letter E, including the tendency to curve itself upwards into the main stem. Lengthening the horizontal member will increase the area between this letter and others, such as LA, and it is best to keep its span minimal except in the case of LT.

M may be regarded as a somewhat wide letter V, propped up by stems on either side, themselves leaning slightly inwards in support. It has a distinctive form of its own and is no more a W upside down than W is an M treated similarly. Care must be taken that the internal angles at the top where stems merge are level, and that the stems' axial junctions should 'hinge' near the top guide line to produce shared areas – diamond shaped in Roman examples; triangular for the serifed tops. If this construction is ignored, junctions are liable to become either crutched **M** or lopped **M**, of which the latter may perhaps on occasions be allowed.

N has attributes akin to M. Its proportions are squarish overall, its points behaving when reaching top and bottom guide lines as already described. Its main feature is the stressed diagonal stem.

O is a key letter as has already been noticed. The angle of its slanting axis cannot of course be laid down categorically but will set the standard for behavioural curvature throughout the alphabet if all the letters are created with the same instrument used consistently. O's shape is circular outside and elliptical inside.

P consists of a letter I plus a bow similar to a small D. The void to its south-east is certainly to be reckoned with when spacing letters.

Q is O with an elegantly curved tail which springs from the lower thin part of the letter; over the centuries lettering artists have tended to flourish this tail.

R consists basically of the letter P with the addition of a diagonal tail which, like that of Q, lettering artists have always been tempted to flourish. There should be some life in this diagonal member to avoid rigid straightness.

The diagonal may leave the bow outwards and descend in a curve, **R**; it may be dealt with soberly as shown in the margin; it may

descend abruptly from the bow to end outwards in a curve, **R**; or it may perform an S-like movement in reverse, **R**. Whatever is done, its projected axis must hit the main stem top, otherwise the tail will either appear inhibited, **R**, or provide no support for the bow, **R**, both creating structural weakness.

S has a diagonal centre, and is not merely parts of two circles one above the other. By reason of its having the full stress only at its centre this bantam-weight letter demands a visual boost to achieve parity with the rest of the alphabet—a thickening of the stem at the centre up to half as much again as the stressed strokes of the other letters. We have noticed how top-heaviness was to be avoided if possible and S is no exception, its lower contained space being larger than its upper one; turn the letter upside down for confirmation of this. In the same way, to appear to lean backwards might look odd, so while the head of S is terminated vertically above its forward curvature its tail is permitted to project very slightly. In this way the letter assumes a progressive rather than a reluctant look which, like the tails of K, R and Q, lends liveliness to an inscription overall. Head and tail are clipped off vertically at a point where the curved strokes turn heavier.

T has a top which will tend to begin and end at the angle a square-ended brush or pen will provide when making the horizontal stroke. For obvious reasons the crossbar of a T will affect the spacing within a word of capital letters and is less troublesome if narrower rather than wider.

U is a later development of Roman V, the base of which has been re-formed as a curve supporting two similar stems. In some versions the right-hand stem is likely to put a foot down upon the lower guide line to keep things steady; this is not necessarily minuscule behaviour as some have thought.

V may be envisaged as an A upside down, less its horizontal member. It is narrow set, and its stems conform strictly to a thick and thin relationship for reasons already discussed.

W is a letter the French more reasonably name 'double vee', being composed of two Vs now linked but once used separately in sequence. For this wide letter each of its Vs may be somewhat narrower than when used alone. Their junction may be pointed, or overlapped and serifed, and the Vs may even be interlaced, avoiding pressurized areas

such as those in figures I and J, left, or those illustrated in the versal W in figure 24.

X crosses its stems to form triangular spaces of visually equal value; that is, at just above the true centre.

Y is narrow set, approximating to a small letter V supported upon the lower half of a letter I. Like T, this letter poses a spacing problem of its own, for example following W or T.

Z is subject to special treatment, as though the stress of its diagonal stroke had been turned 90° to give a weight to rhythmical spacing which would otherwise not be there. This letter, originally the ancient-Greek zeta, was dropped by the Romans and was restored after 31 B.C., at first only to express zeta in words borrowed from the Greek.

2

The letters spaced

It has been claimed that skilled arrangement of indifferent letter-forms succeeds overall better than the reverse. Certainly, for optimum results, care over the shapes of letters deserves a matching care in their arrangement. This requires skilful visual judgement in posing a sequence of letters into a rhythmical progression of stems, much like the rungs of a ladder laid on its side – more complex though because some of these 'rungs' are curved or oblique, or mixtures of both. Such visual judgement is not easily acquired, and lack of it may encourage the comfortable notion that strict rhythms may be monotonous anyway and variety is the spice of life after all.

Letter sequences are of great variety in any language but certain combinations cause especial disruption to an otherwise rhythmic progress, and only experience makes for awareness of those instances which would adversely affect the word flow. Take the word 'THE' for example: since **TH** cannot approach each other more closely because the crossbar of T gets in the way, E must be stood off accordingly if a visual balance is to be maintained between stems, giving **TH E** rather than the more frequently seen **THE** . It will be seen that though the letters of the latter may be distanced apart equally, their stems are spaced unequally since the two interletter areas⌷ ⌷do not equate. As Hugh Williamson, a leading authority on book design, has pointed out, being mechanically even is not necessarily the same thing as being optically so. Were one to walk back from the two words the thinner horizontals would vanish first, leaving stems ⅠⅠⅠⅠ if well spaced, or ⅠⅢ if badly, since T and H are kept apart by T's crossbar while nothing but a sense of spacing would prevent H and E from being placed close together.

In the word 'LAW' the juxtaposition of the letters **LA** produces a gaping space between them; W must be put at an appropriate distance to produce an even spacing thus: **LAW**, rather than **LAW**. Though close spacing might just do for the word **WAVE**, it would not work for the word **WAVY**, where the combination of **VY** defeats any hope of rhythm, unless previously allowed for.

Because two Os curve away from each other they may be brought more closely together, say one stem-width distant, to produce an area shaped){. For the word **HOOD** therefore this area should equate with that between H and O, ⟨, as well as the reversed shape, between O and D, ⟩.

The serifs of an alphabet enter very much into its spacing considerations since long serifs tend to shut up the areas within the letters C, E, F, S and Z, while the absence of serifs opens them. A very heavy sanserif **E** is virtually closed anyway but that is a special case discussed later.

The area between **EA** may be thought of as ▽ but without serifs it

could well include the interior of **E** as well, &7, or, discounting the horizontals if very thin, could even be counted as ☐/ from stem to stem, nearly twice as much. A proved helpful way to arrive at well-spaced words is to preview the letter sequence in overlapping groups of three at a time. For example, what is really wrong with the spacing of **SHILLING**? If S and H are in good spatial relationship then the first letter I must be moved over to the right until H is visually centred, **SHI**. Since these three are now in visual balance L must be moved away from I an appropriate amount. The second L should now be brought in as close as the first L will allow (and in this respect a narrowish L is a help). The second letter I must now close in as far as the second L will allow to perpetuate the rhythm of stems already established, while N must be stood off to maintain it. Finally G will need positioning so that the interletter area ℂ will match that between the other pairs of letters, in such a way that **SHILLING** shows each of its letters visually central between its immediate neighbours.

So far we have only discussed letters arranged in horizontal lines, but in the case of capitals arranged in a circle, assuming that they go round with their tops outwards, it will be appreciated that gaps produced by combinations such as ⌒LA⌒ will be aggravated, while the spatial problems of ⌒IT⌒ or ⌒IY⌒ will be lessened. Letters will not of course look their best if their stems are blindly treated as spokes of a wheel, ⌒M⌒, and even worse if the wheel notion is carried into the horizontals, ⌒H⌒. It is perfectly possible to fit the centres of stem-endings of Roman and many other styles of capital letters into a circle. If some serifs are slightly inside and some slightly outside it does not matter at all. The main thing is that the visual centre of each letter aligns with imaginary wheel spokes, and that letter tops are enough apart to avoid congestion below.

Designers of commemorative plaques or panels of numerous lines may find it helpful to set out the words of the text in one continuously spaced sequence upon strips of paper stuck end-to-end together with evenness as a priority. These can then be cut up into a suitable arrangement. Practice makes for good guesswork and minor modifications are always possible. Frequently more than one of these preliminary layouts are made for each task. In penmanship, however, it is not always appropriate to write out the letters beforehand as this would be the equivalent of doing the work twice. Ideally, from the practised calligrapher comes a steady flow of letters, uninterruptedly formed and unerringly spaced. It should be known with some confidence what one's own work measures, and there exist similar considerations in the flow of photocomposed typesetting for printing purposes.

Visual aspects of the comprehensibility of text have been extensively researched by Christopher Poulton of the Medical Research

Council, Cambridge, and by the Spencer study group in readability of print at the Royal College of Art in London. It is due to the specialized work of the alphabetist David Kindersley of Cambridge that the idea of an optical letter-spacer for the photocomposition of type is now being carried into the computer-assisted phase – instant recognition of letter-forms and their groupings or positioning into a balanced sequence, much as the human eye, brain and hand are co-ordinated in calligraphy. The freedom from restrictions of cast metal type given by photosetting has produced new responsibilities such as arise in the wake of most other kinds of emancipation. Tight or very tight letter-spacing in photocomposition certainly reduces paper cost, but results in dark patches throughout the text where stems associate too closely, especially in sanserif styles. Obviously, normal or loose letter-spacing is desirable if dignity and legibility are to count. The alternative is a smaller letter size treated with decent breathing space, since scarcely anything could look worse than irregular groups of congested stems in an area of text.

Largely as the result of Kindersley's research, many sheets of transfer-lettering, such as Letraset, and other alphabets widely used in place of practised lettering skills, now incorporate some guidance in the matter of spacing. The user retains, however, the ultimate responsibility of how the working letters in such alphabets are best presented.

Roman capital letters at work

Letters were often assembled by the ancients to serve as records of events or expressions of thought, to be read and assimilated largely in public situations, for the purposes of government, commemoration and worship. David Diringer has set out in his great work *The Alphabet* (1948) the evolution which led letters to their formal presentation by the Romans. In simplest terms what we now call Roman capital letters were derived from the Semitic alphabet by way of the Phoenicians, Greeks and Etruscans.

From the first century B.C., Latin inscriptions carved in stone were produced throughout the Roman Empire, eventually to provide models for the scribes of the West, in their massive transcriptions of ancient classical literature, laws and histories, and in their later articles of Christian faith.

For a while, therefore, letter-form deferred directly to the older lapidary capital letters. At the same time, both in stone and upon writing materials, a faster condensed version of them, now known as 'Rustic', was brought into use. But it was the older forms that survived in the early book production of western Europe, in turn to become less angular and more curved in the penman's hand, leading to what we call 'uncials', or rounded capitals, eventually into half-uncials and so into true minuscules in all their national varieties. Today it is entirely right that we should look yet again at the Roman alphabet of capital letters, which has been diversified and harnessed into innumerable forms and usages.

2. Roman alphabet forms.
Example by William Gardner.

Originally incised on stone, these forms remain suitable for engraved and painted lettering generally

ABCDEFGHIJK

narrow stems about halfwidth of main stems

All straight stems slightly waisted — curved stems based upon letter O. Serifs adaptable.

LMNOPQRST

W. European calligraphy and typography derive from this alphabet Alternative tops

UVWXYZ AM

Stems average nine squares high

3. Pompeii Theatre alphabet.
William Gardner after Emil
Hübner.

By common consent the inscription in stone eulogizing Emperor
Trajan at Rome is considered unsurpassed in the beauty of its letter-
form. According to Edward Catich the cutting was completed during
the year A.D. 113. The exemplar (2) on page 11 is freely based upon the
Trajan model, though somewhat heavier in weight and with letters
H, J, K, U, W, Y and Z added *en suite*.

Letter for letter the Pompeii Theatre alphabet (3), cut *c* 27 B.C.–
A.D. 54, compares very favourably with that of the inscription in
Trajan's Forum at Rome. Words are separated by the customary
triangular point in both cases. The Trajan R droops its tail somewhat,
but the Pompeii R (as in CELER) has outstanding dignity and verve.
In the Pompeii example T is consistently fitted upwards to accommo-
date the sequence of stems – an early example of letter-fitting of a kind
extensively used in modern display work.

It is the ageless need for commemoration which has perpetuated the
Roman letter-form. Eric Gill, a student of Edward Johnston at the turn
of this century, in due time became the leading twentieth-century
letterer in stone. Gill's model was the Trajan alphabet which he virtu-
ally made his own. His inherent taste and ability were opportunely
harnessed to a widespread demand for commemoration following the
First World War, and his craftsmanship coincided with the availability
of stone from Hoptonwood and other fine beds, since virtually worked
out. From letter-cutting in stone, Gill's interests encompassed wood-
engraving and typeface design, but it is his incised Roman letter-forms
which are especially relevant, and those shown here are cut in
Hoptonwood stone, which is conducive to great clarity of definition
and the utmost refinement of serifs. Flints embedded in it provided
no problem for his well-tempered chisel and sensitive technique. This
illustration (4) is from an exemplar of 1927 now in the Victoria and
Albert Museum, London.

Herbert Joseph Cribb was both apprentice and assistant to Eric Gill,

4. Roman inscriptional alphabet cut by Eric Gill, 1927. Victoria and Albert Museum.

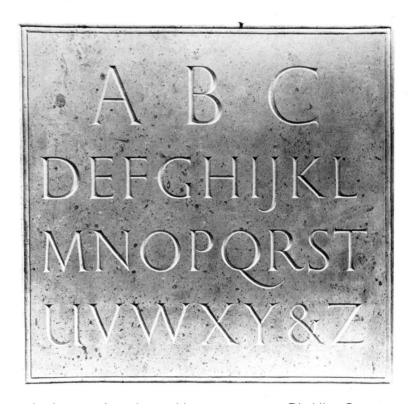

and subsequently active on his own account at Ditchling Common, Sussex, until his death in 1967. A foreshortened view of a stone to the memory of Ernest William Sprott (5) is shown in the workshop with its inscription partly cut. The letters are Trajan style and are not only cut exceedingly crisply, but deeply enough to avoid the need of painting into the stems, something which this craftsman always stressed. A close look at the five As, three Bs, five Ds and four Os reveals a consistency of the highest order yet without the slightest loss of liveliness, coupled with an overall grasp of arrangement which takes in its stride such spacing problems as S U A E on the fourth line.

Reynolds Stone was master equally of the chisel and the graver. In the five hundred and more examples of his engravings on boxwood published by John Murray in 1977 under the title *Engravings*, most of which incorporate lettering of some kind (6), there is a wonderful consistency of letter-form and impeccability of spacing over a period of forty years, with scarcely any discernible changes of practice between wider and narrower forms. Capital W of two hinged Vs is seen gradually to take the place of one in which its second V partly obscures its first, but there is unremitting belief in a round-based capital U stressed only in its first member, and no other artist's lettering to the writer's knowledge has vindicated better the test of overlapping trios of letters as discussed in Chapter 2.

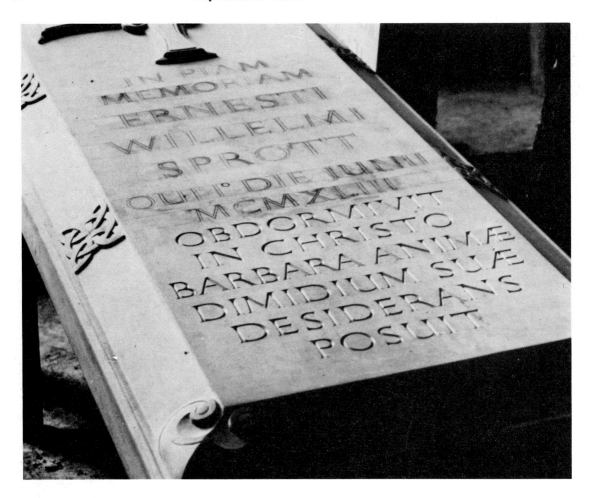

5. Sprott memorial stone by Joseph Cribb.

Laurence Cribb, H. Joseph Cribb's brother, assisted Eric Gill at London, Ditchling, Capel-y-ffin in Wales, and High Wycombe, Buckinghamshire; and it was he who carved Gill's headstone and foot-stone in Speen burial ground, also in Buckinghamshire, as well as the tablet to Gill's memory in Westminster Cathedral. In figure 7 a rich yet gentle texture of letters has been attained, with subtle emphasis on names. Variance of size and weight allowed, questions about this inscription might well include: How much should names be empha-sized? Should dates be cut large or should they be equal to or smaller than names? Are contractions acceptable? For instance, should the names of the months be in full wherever possible, and would the words 'twenty-sixth' be better than their equivalent in numerals? The answers to these and other questions vary and workshops establish their own codes covering such contingencies.

This detail of recent chisel-forms cut in York stone by Michael Renton (8) is an excellent example of the intrinsic beauty of Roman

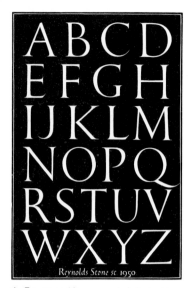

6. Engraved boxwood alphabet by Reynolds Stone, 1950.

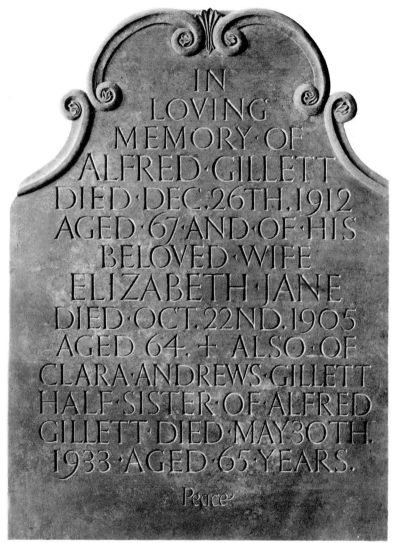

7. Gillett memorial stone by Laurence Cribb.

letters. The keynote is simplicity, while the top lighting reveals sensitive serifs and an exquisite follow through of curved stems. The slight triangulation where the two bows of 3 meet is an established feature of the Gill school of lettering; and this form of capital letter U is in harmony with the steadiness of the inscription overall. The dates gain importance from the lighter-weight treatment of the line of qualifications above them, while spaciousness between the lines themselves enhances this most delicately cut and tranquil inscription.

Above is an area from a commemoration of some 750 Roman capital letters engraved by the author in plaster-of-Paris for casting in bronze (9). Here the aim was that the letters should follow one another rhythmically in harmony with the alphabet on page 11. Consistency of

8. Elio Montuschi memorial stone by Michael Renton.

9. Batterbee memorial plaque by William Gardner.

interletter, interword and interline arrangement secures, it is hoped, an even texture overall. Serifs, being clearly defined, are of essential assistance to the reading of lengthy line spans, while an incised V section of 90° is calculated to ensure optimum legibility from the internal facets of letter stems both straight and curved.

The Holborn workshop of George T. Friend was for many years, until his death in 1969, a magnet for those with lettering requirements in engraved metal. Himself a designer and creator of innumerable masterpieces of commemorative work, he was also a willing collaborator with Alan Wyon, Edward E. Dorling, Eric Gill, MacDonald Gill, George Kruger Gray, Edward Johnston and many other well-known artist-craftsmen of his day. The plaque illustrated (10) was in fact engraved by him and designed by Eric Gill. Engraving in metals

10. Silver plaque engraved by George T. Friend from Eric Gill's alphabet(s). Goldsmiths' Company, 1934.

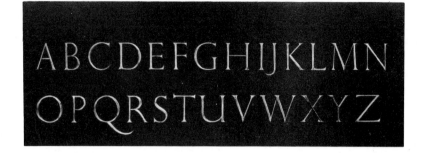

11. Road name alphabet by David Kindersley for the Ministry of Transport.

of all kinds, and gifted with an instinctive sense of letter-form and its arrangement, George Friend produced an exceptionally rich body of work which included the rare skill of punch-cutting.

David Kindersley has contributed an outstanding version of the Roman alphabet for street-name purposes (11) which more and more local authorities are taking into use through the sponsorship of the Ministry of Transport. Closely allied to his typeface Scintilla, it has several notable features in addition to its excellent legibility. The serifs are denied by curtailment the visual power to bulge stems of parallel construction but are perfectly adequate as endings. There is a subtle calligraphic stress throughout, more noticeable in E, F and G. The tails of K and R give a liveliness, the latter frequently recurring in the word 'ROAD'. The sharp points of V and W are trimmed into defined endings, while round letters fractionally exceed their hypothetical guide lines in order to appear visually within them. Internal angles of less than 90° are curved to accommodate the softening action of the engraving drill known as a routing machine. Each letter is centralized visually into a rectangle as spacing guidance, the validity of which is clearly demonstrated when reading this alphabet as one long word. Very close inspection, however, reveals a tendency for certain letters

12. Signwritten list of Royal Designers for Industry. William Sharpington and Sidney Bendall. Royal Society of Arts.

MARIANNE STRAUB	1972
BØRGE MOGENSEN (Honorary)	1972
NOEL LONDON	1973
GEORGE MACKIE	1973
RICHARD STEVENS	1973
WALTER TRACY	1973
HOWARD UPJOHN	1973
GEORGE NELSON (Honorary)	1973
PAUL RAND (Honorary)	1973
ROGER TALLON (Honorary)	1973
EDWARD ARDIZZONE	1974
DAVID CARTER	1974
HULME CHADWICK	1974

to lose their alignment. L doesn't quite stand down, and T won't quite reach up. Z, not that we are likely to see much of it, touches neither floor nor ceiling but floats in its rectangle, a slightly smaller letter than the rest.

The story of the design of vehicle registration alphabets and numbers, a saga on its own, is also the preserve of the Ministry of Transport.

In this illustration of signwritten gilded letters upon wood (12), Sidney Bendall takes over the work of the late William Sharpington. It is part of the list of appointments to the Faculty of Royal Designers for Industry, formerly at the Royal Society of Arts in London, and it is hard to spot the point of changeover.

Finally, to illustrate a more relaxed arrangement, one may cite the well-known New Zealand sculptor Paul Beadle's delightful letterhead (13). Its calculatedly free yet tranquil sequence of greenish-grey Roman capital letters carries the day in spontaneous and architectural integrity.

13. Letterhead by Paul Beadle.

PAUL BEADLE · SCULPTOR
FRITZ HENRY COTTAGE
MARAE ROAD GREENHITHE
RD 4 ALBANY · NEW ZEALAND
PHONE · GREENHITHE · 635

Typefaces

Of typefaces designed during this century which follow the basic Roman formula, the following can claim eminence.

Johnston's Railway Type (1916)

14. Edward Johnston's Railway Type. London Transport Executive, 1916 –18.

ABCDEFGHI
JKLMNOPQR
STUVWXYZ

Designed by the scribe Edward Johnston, this alphabet (14) has worked long and hard for the London public-transport systems. It is a distinguished face which, unlike many sanserif styles of earlier and later origin, defers strongly to Roman alphabet proportions. One less Roman feature is an M with a raised central point, by no means an innovation, and although this ensures an uncrowded interior for the letter, there is some loss of character. The Q's tail is perhaps over-contrived, but this is an alphabet of great dignity and legibility which has stood the test of time.

Albertus (1934-5)

15. Typeface Albertus by Berthold Wolpe. Monotype, 1934–5.

ABCDEFGHIJK
LMNOPQRST
UVWXYZ&

Evolved by Berthold Wolpe, the face (15) reveals this artist's deep feeling for the alphabet in several crafts, not least the carved letter. The overall character of Albertus is both rugged and crisp, all the round letters except D being given their head. There is a sense of calligraphy throughout in spite of scarcely noticeable reversals of

stress in the diagonals of A, K, M, V, W, X and Y. This typeface has provided a most powerful and satisfying contribution to display typography in modern times.

Castellar (1957)

16. Typeface Castellar by John Peters. Monotype, 1957.

ABCDEFGHI
JKLMNPQR
STUVWXYZ

This display face devised by John Peters (16) possesses marked spaciousness and elegance, with lengthy and sharp serifs. The overall widths of L and T demand spacious settings, while X might be thought unduly wide, but the strong base of U with its stems of equal weight achieves notable visual steadiness, and if Q must retract its tail in the cause of titling requirements – to obviate interline problems caused by ascending or descending members – then this Q tail does so perfectly. It is a delightful alphabet.

Optima (1958)

17. Typeface Optima by Herman Zapf. Stempel, 1958.

ABCDEFGHIJKLMN
OPQRSTUVWXYZ

Designed by Hermann Zapf, this typeface (17) combines the Roman model with sanserif style in a most agreeable and convincing manner. It is, in effect, the ageless monoline, or simple unstressed, pattern given a degree of traditional stress; and in either its normal or bold weights it possesses maximum clarity. It is also more responsive to spacing skill than some of its users seem prepared to give it. This very explicit and sensitive design is one which demands nothing less than the very best usage.

18. Typeface Perpetua by Eric Gill. Monotype, 1925.

Perpetua (1925) and Times New Roman (1931-2)

ABCDEFG HIJKLMNOPQRS TUVWXYZ&

19. Typeface Times New Roman by Stanley Morison. Monotype, 1931–2.

ABCDEFG HIJKLMNOPQRS TUVWXYZ&

It is of worthwhile interest to make a close comparison between these two typefaces: Perpetua (18) as designed by the letter-cutter Eric Gill, and Times New Roman (19) as designed with the assistance of Vincent Lardent by Stanley Morison the typographer. To throw the two alphabets together is to see something of their originators' different personalities and methods of approach; where they meet and where they are seemingly at opposite poles.

Morison's Times New Roman was evolved from Robert Granjon's Gros Cicero typeface cut in 1568, but influenced by the sharper serifs and greater contrasts of Gill's Perpetua which Morison had at first thought to use in modified form but eventually rejected.

Perpetua is in many respects closer to the Roman inscriptional style than Times New Roman. The flat top of Gill's narrower A makes it appear to align better with the rest of the letter tops than Morison's pointed A which is aligned at its extremity only and is therefore visually short. Gill's B is again more Roman, being narrower, while of the two Cs their only difference is that Morison's C's head ends at a slight angle. Gill's G is gentle in the modest length of its straight stem, while Morison's stem is taller and more dominant. The stems of H are set more apart by Gill than by Morison, and Gill has raised very slightly the central member to avoid a drooping appearance. The most noticeable contrast of all is that Gill's stems are incurved while Morison omits

this refinement in favour of parallel sides which, because of the addition of serifs, appear to bulge. The chisel has suggested an ending for Perpetua's J, but the press has no particular need for such sharpness and can make do with Morison's blob instead. The toe of Gill's K is fancy-free while Morison favours the stability of the suction pad, something of which the Romans themselves made occasional use. The Ls of both alphabets are generously wide. Gill's M might be thought of as oversplayed, while Morison's could almost look turned in on itself in the face of strong diagonals. The two Ns differ only in their width, Morison's being slightly the narrower. The O and Q of Perpetua are rounder than those in Times New Roman, but of the two letters P Morison's is slightly the wider. The tail of Gill's R flows outwards and downwards before ending sharply, while Morison's R struts diagonally to its ending without the rearward spur of his K. In both alphabets the letters S lean visually backwards from shortness of head, and are weak because their middles do not compensate for their thin terminations. The serifs give Gill's T a buoyant aspect while Morison's T, avoiding any encroachment into the space above the bar, looks depressed. The U of Perpetua recognizes the fact that two downward strokes made identically with the same instrument will be of equal visual value, whereas the U of Times New Roman adheres to the theory that a letter V of two unequally stressed stems can be bent into a curve at the bottom; furthermore Gill's letter U puts one foot to the ground for stability. The W of Perpetua is of two Vs hinged together centrally where they meet, while the second V of Times's W partly obscures its first in the cause of condensing this otherwise rather wide letter. Gill's X is slightly wider than might be expected, and Morison's Y might be considered the less couth of the two. The Zs are differentiated slightly only in their widths, though Morison's has a shorter head. Surprisingly, although both ampersands defer to calligraphy, the letter-cutter follows closely the common form of late fifteenth-century Venetian printing, while the typographer comes up with a version one might have expected to find with Perpetua, and very slightly slanted towards italic.

A woodcut alphabet of capital letters provided by Eric Gill for the use of the Golden Cockerel Press in 1929 is almost letter for letter identical with his Perpetua design, and from the similarity of the two it is clear that Gill's personal attitude to the Roman alphabet had long been formulated. Only the generous breadth of his woodcut H and the irresistible flourish to R's tail seem to have been controlled for Monotype for Perpetua, doubtless on the grounds of these two letters' greed for space.

4

Versal letters

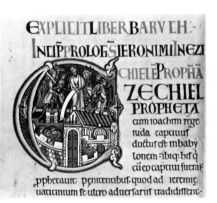

20. Versal letters from the Winchester Bible. Dean and Chapter Library.

21. Versal capitals. Example by William Gardner.

Graily Hewitt, the well-known scribe, pointed out that it was Edward F. Strange, in his 1895 handbook *Alphabets*, who first distinguished between initial letters to begin things with and versal letters to mark verses or sections as guidance in the reading of liturgical books. It is unlikely that their medieval users had any name for versals, being simply Roman letters drawn large with a pen in red or blue or green, and sometimes, where the importance of the manuscript justified it, rendered in burnished gold.

Versal letters used as headings are strictly majuscule, intended to catch attention through their size and visual authority. Of the several different kinds, a good illustration of such use may be taken from the renowned twelfth-century Bible of Winchester Cathedral Library (20). The reference here, in squarish versals of more than one colour, is to the book of BARUCH (incidentally including a fine example of a colon followed by a dash) and to the prophet EZECHIEL; a large rounded initial Є, the central member of which is somewhat hidden by the contained action, dominating the vellum page.

For the versal letters below (21) the pen's point is not required to be as sharp as for the later copperplate styles of writing. In fact it should be wide enough to give some body to the outlining, for instance of the open letter I, on the left. Three more such downward strokes could fill this stem with colour. Serifs are added with the same pen's edge, and on occasions their careful placement beforehand may be used to predetermine the extent of a stem drawn between them.

This title page of The Book of Remembrance, Corps of Royal Marines (22), shows versal letters blocked hot on to the vellum in gold foil. Letters raised separately in relief by means of a bodied adhesive upon

ABCDEFGHIJKLMN OPQRSTUVWXYZ &

I Stems waisted Outer curves, sharper than inner curves. O E Pen held normally for most main stems and curves, but turned for horizontal stems of letters A E F H LT and Z

Some permissible variations and flourishes *Decorative medieval styles, overpopularised in the nineteenth century, now not generally used*

 AEGJLNR ABCDEFGHIJKLMN OPQRSTUVWXYZ3

22. Royal Marines' Roll of Honour title page in gold by William Gardner and Sydney M. Cockerell.

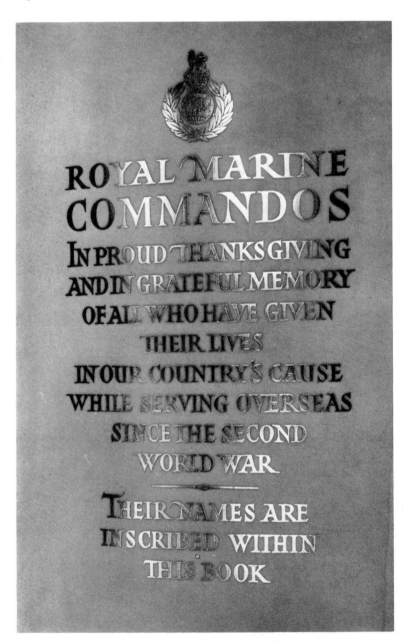

which gold leaf is laid and subsequently burnished to a mirror finish are costly both in materials and time. The characteristics of letters made in this way include reflection of light, especially along the 'shoulders' of the relief, resulting in a lively sparkle when the page is turned. Such gold surfaces, though reasonably resistant to wear and tear, are liable to sustain scratches and abrasion. In this title page the gilded stems are fractionally below the surface of the vellum page and

23 (above). Title page. Record of Arms in the Great Cloister, Canterbury Cathedral. Dean and Chapter Library.

24 (below). London Transport Roll of Honour title-page design by William Gardner. London Transport Executive.

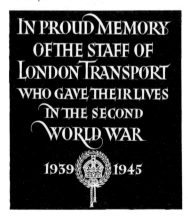

25. Scroll from a drawing of the Arms of the Leathersellers' Company. William Gardner.

to that extent protected, yet having a three-dimensional form they catch the light at their edges as much as if they were in relief. A brass block, made from the artist's black-and-white drawing, was pressed at an appropriate temperature direct into the vellum over gold foil and several pressings were made to build up the required intensity of gold. The pressed title page was accomplished in Sydney M. Cockerell's bindery, for the author's manuscript.

This large illuminated manuscript (23), completed in 1939 and now in the Dean and Chapter Library, is a record of the restoration of carved heraldry in the vaulted ceiling of the cloisters at Canterbury Cathedral. The author was responsible for the overall design and penmanship of the manuscript, while the late Norman Ball laid and burnished the gold letters. The painting throughout was by Tom Wrigley. Douglas Cockerell and Son bound the volume in oak boards with a tawed alum pigskin spine and silver clasps by Val Mitchell. The task was supervised by Professor Ernest Tristram and was tackled with a degree of claustral discipline: script, rubrication, drawing, gilding, painting and binding – in that order. The versal capital letters of mirror-finished burnished gold set off the colours of the heraldry above them and throw the light around when this leaf is turned. The words 'CANTERBURY CATHEDRAL' stand out in size and spaciousness, with what follows massed intentionally into a golden texture.

Here is another panel of versal letters (24), this time drawn in black on white for blocking with gold foil into the vellum title page of London Transport's 1939–45 War Memorial Book inscribed by the author. The letter-form is narrow and serifs are shared frequently throughout. An even progression of letters is intended, and the R of WORLD is flourished through D back to L as a link with the wreathed crown below. As we shall be discussing later, although versal letters had been in use before the Norman Conquest, Arabic numerals were scarcely used in England until early printing demonstrated their superior convenience over the Roman system. So these dates are in careful pastiche to accompany a versal alphabet. Ideally the two Vs of each bottom line W could have been interlaced in such a way that internal spaces were evenly disposed and not squeezed towards the top–centre; the letter X might have provided the criterion for crossings at the middles of such Ws.

Here is an example of compromise between the Roman alphabet and versals (25). The stems are vigorously incurved and their serifs link up in a letter flow upon the scroll of a library arms block designed for the Worshipful Company of Leathersellers. There is no pretence at Roman proportions, the lettering being arranged as a rich band of patterning.

ROYAL HORSE GUARDS *The Blues*

26 (above) and 27 (right). Royal Horse Guards Book of Remembrance. Title design by William Gardner and binding by Sydney Cockerell.

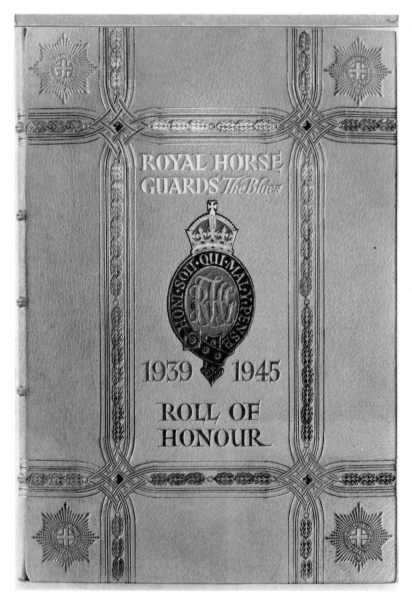

Versals are similarly adaptable to bookbinding, and blocks made from drawings may be pressed into leather using a heated arming press with gold foil. Figure 26 is a drawing for the front coverboard of the 1939–45 Royal Horse Guards' (The Blues) Roll of Honour, now in Wellington Barracks Chapel, London. The impression upon white goatskin (27) is deep enough for its shoulders to catch a lively sideplay of light upon the gold shapes of the letters. The impression is by Sydney M. Cockerell from letters drawn by the author.

Opposite is a drawing by the author for use by Cheltenham College in Gloucestershire (28). In the absence of any crest above the helm, an

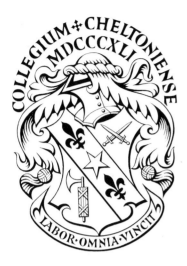

28. Cheltenham College logo and bookstamp by William Gardner.

arched double band of letters, including a Roman-style date, echoes the curvature of the scroll below the shield. These letters are again what might be termed 'Roman versals', providing a richly patterned semicircular area above to complete the composition of a tall oval, for use either as a library bookstamp or letterhead logo.

5

Written capitals

Perpetuation of the Roman alphabet was at first effected by scribes endeavouring to reproduce 'square' capitals, upon the vellum leaves of books in codex form, and wonderfully well these were expressed to begin with. Figure 29 comes from a fifth-century Virgil manuscript in the library of St. Gall, Switzerland. The need for an increased copying speed along with a marked squeezing of texts on to less writing material must have proved a valuable economy, especially for works of any length.

At the beginning of many manuscripts of the early centuries A.D. several lines of square capitals are frequently followed by the faster, rounder, and more easily accomplished Rustic hand, as this style is now called. Its survival may be noticed with the lines of versals which so frequently introduce Romanesque manuscripts, followed by the national minuscule book-hand of the day. Square capitals and Rustic capitals coexisted both as inscriptions on stone and as penned letters in books. Figure 30 is an example of Rustic writing from the Vatican Library's copy of Virgil of the fourth or fifth century in which the pen is used right-handed at some 60° from the horizontal, weakening the main stems, stressing horizontals, and producing an overall textural grain from top left to bottom right.

It was not long before an escalation of copying of Christian literature

29. Square Capitals. *Codex Sangallensis* (Virgil). St. Gall, Stiftsbibliotek. MS 1394, 5th century.

30. Rustic Capitals. *Codex Palatinus*30. Rustic Capitals. *Codex Palatinus* (Virgil). Vatican. Latin MS 1631, 4th–5th century.

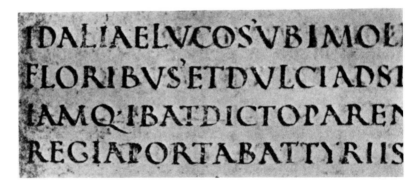

led to the further emancipation of the scribes and to a style of writing we now call 'uncial'. Lowe maintains that the true meaning and origin of this word is still in dispute, though since the eighteenth century it has been associated with the rounded style of majuscule lettering. Uncials provided a further economy, this time in letter strokes at the hand of the penman. D is in two strokes instead of three; E is in three instead of four; H is in two instead of three, and so forth. The uncials illustrated (31) are from a gospel book of vellum leaves written in southern England in Anglo-Saxon times, now in the Kungliga Library, Stockholm. They are highly accomplished letter-forms, by no means out of harmony with the versals we have already discussed.

The uncial form has been used with distinction in the twentieth century by a number of scribes. Hedwig Reiner employed for the title page of his *Lettering in Book Art* a subtle example of personal beliefs and disciplines (32). There are several unusual features: a large upper bow for B, almost as though Roman B had been envisaged upside down and in a mirror; the comma-like dot seems hardly necessary to distinguish letter I; Ns are footed; and the pen is manipulated in a most arbitrary way in places. Yet the whole is most satisfying and highly

32. Modern uncials by Hedwig Reiner.

BRIEFE DER HERZOGIN ELISABETH CHARLOTTE VON ORLEANS

31. Uncial letters. *Codex Aureus.* Canterbury work. Kungliga Biblioteket, Stockholm, MSA. 135.

ABCDEFGHIJKLMN
OPQRSTUVWXYZ&

Stems about 7 nibwidths high — THE Æ LA OR VA DOE

Below, varieties and flourishes for occasional use. Above, examples of shared stems, overlapping, interlacing.

AEEFGGJLMNT

Effective angle of nib about 30°

33. Basic Script capitals. Example by William Gardner.

accomplished, with a splendid sense of spatial values including a totally acceptable double T, **TT**.

Few books are produced today in capital letters alone. We are conditioned to the minuscule letter-forms which have evolved down the centuries from the capitals used originally as book-hands. Although there is no technical reason why a modern book should not be printed in capital letters, problems of economy and readability weigh against such an undertaking: a book in capitals might take longer to produce, would use more material size for size and be tiring to read continuously for any length of time.

In the example (34) of Edward Johnston's penmanship (from page 30 of the *Book of Sample Scripts*, commissioned by Sir Sydney Cockerell in 1914) the Latin has that inherent visual dignity it displays even more in minuscule form where there is a comparative lack of oblique strokes. Johnston described this example very briefly as 'Roman Capital MS, based on Sq. Caps of 3 or 4 or 5 centy'. A lively action attends the horizontal strokes of E, L and T, while the double-ended tail of the second Q reveals a speed of execution too great to allow the pen to turn and complete the flourish on one point only.

Capital letters are extensively used both in display printing and in most fields of hand-produced letter-work. Figure 35 is typical of the customary filling-in of vacant oceanic areas in maps by means of flourished capitals, in an attempt to balance the congestion of place names upon land. In this instance a series of maps, commissioned for the Brussels Fair of 1958, made use of script capitals at a size consider-

34. Capitals from *A Book of Sample Scripts* by Edward Johnston. H.M.S.O.

ET OSTENDIT MIHI FLVVIVM
AQVAE VITAE, SPLENDIDVM
TAMQVAM CRYSTALLVM,
PROCEDENTEM DE SEDE

35. Flourished Basic Script capitals from a map by William and Joan Gardner. Brussels Fair, 1958.

ably larger than convenient for penmanship. Two pencil points were fixed apart to define the width of the letter stems and were put through the correct motions upon a white surface; the background was then rendered in a dark tone leaving the letters white between the pencilled lines.

Minuscule writing

The evolution of minuscules from capital letters took place gradually over a period of centuries, and is far too complex and diverse to investigate fully here. Basically, minuscules are capitals simplified by the scribes in their search for economies.

The letter A was more freely rendered by the penman as λ, later as α, later still as a, with loss of its top altogether in handwriting, a. B shed its upper bow as it was more quickly performed, and C remained much the same. D became uncial with the top of the letter flourished over a curved left-hand stem, δ, eventually to turn a quarter circle clockwise into d. E saved a stroke by eliminating its upper and lower angles into ϵ, until its top member joined the centre bar into e, ultimately into a rounded version, e. F rounded its upper angle into f. G went through gymnastics, G, g, g, g, into g, still retaining the capital's curved top, with the further option, g. H lost the upper part of its right-hand stem, and rounded the result, h. The letter I stayed much the same as a single stem, but fourteenth-century scribes were obliged to distinguish it from so many other similar stems by means of a tick or dot above, in such words as **minimum**. J simply dropped itself below the line, whereas K shortened its upper right-hand member into k or turned it inwards into k. L rounded out its angle into l. M exchanged its four diagonals for three vertical stems with rounded links, m; N behaved similarly. O shrunk, while P simply descended like J. Q 's characteristic tail as a capital initial letter could not very well ⤵ slash through lines of text so was turned downwards into the margin of the page instead, eventually becoming q. R increasingly detached the junction of its bow and tail from the main stem, R, R, r, r, r. Sometimes to save space O's second stem was made to serve as R's main one, OR; even in handwriting we find or. S tucked its tail progressively more closely against its main stem $S \int f$, to become f, the 'long S' in old print (distinct from f), but survives as a smaller version of the original capital letter, s. T took on a rounded form of stem in the uncial role but straightened up again eventually as minuscule t. U developed its rounded base from Roman V, through Rustic V, uncial u, eventually into u. V stayed as v. W or W being in fact more correctly double V than double U, retained its angular bases, w. X was simply reduced to x, while Y dropped its stem below the line into a tail, y. Z remained z but sometimes appears in handwriting with a decorative looped extension to its lower limb, z.

The ampersand is well known as the word 'and'. It is in fact an amalgamation of the Roman letters ET (meaning 'and'), with the lower member of the curved form of ϵ or ϵ extended as the stem of T with its cross-top added, G or $\&$, eventually becoming $\&$. In handwriting a quarter turn anti-clockwise produces the symbol ψ or the varia-

36. Half uncials. St. Hilary *De Trinitate*. Vatican, Archivio della Basilica di S. Pietro. MS D. 182. Before 509.

tion ᴪ. Scribes, signwriters and engravers have always enjoyed an exaggerated use of this delightful symbol, as have typographers no less, while children in school were required to scrawl it separately on their slates after letter Z in the days when the alphabet was learned that way.

The evolution of national book-hands went on more or less independently as each west-European country developed its own writing style out of uncials, through half-uncials, into true minuscules.

This Latin half-uncial book-hand (36), probably of the early sixth century, is full of the significant changes outlined above, with ascending and descending strokes overlapping between lines and some of the letters already crystallized into now-familiar forms. Though capital N lingers, r, g and d are almost there.

The national styles of minuscule penmanship have been grouped by palaeographers into Insular (Britain and Ireland), Visigothic (Spain and Portugal), Lombardic (northern Italy), Beneventan (southern Italy), and Merovingian (Frankish Empire); and while we cannot discuss these here, one book-hand emerged as all important. In A.D. 789 the Emperor Charlemagne decreed that there should be a massive increase in writing. This edict was directed towards the revival of learning and the copying of books, especially at Tours. It was there that a most legible and fine-looking style of writing, now known as the Carolingian minuscule, was encouraged, and perfected in use by the Englishman Alcuin at the Emperor's invitation. The lines illustrated here (37) date from the early ninth century and were written in the Abbey of St. Martin at Tours, and it was this reformed book-hand which later spread through Europe, eventually to become formalized as the lower case of the Venetian printing press. Two well-arranged lines of uncials draw attention to the rest of this script which itself has an air of forward-pushing speed, although by no means anticipating the slanted italic hands of some six centuries later.

37. Reformed Carolingian book-hand. Early 9th century, Tours. Quedlinburg.

38. From *A Book of Sample Scripts* by Edward Johnston. H.M.S.O.

overcome, to open the book and the seven seals thereof. And I saw in the midst of the throne

By the beginning of the fifteenth century a and t had been straightened up, r was no longer permitted to create gaps within words, and g was almost closed into its modern form. 'Long S' persisted in print even into the seventeenth and eighteenth centuries.

Moving on to more recent examples, here are more lines from *A Book of Sample Scripts* (38), in which Johnston demonstrated the steadiness derived from the addition of substantial feet to stems and tails but finds no reason, capital letter I excepted, to add equivalent terminations to ascenders. There is a pre-eminent strength in this writing and in its arrangement, in spite of the relaxed rhythm of stems.

Minuscules or 'lower-case' Basic Script (39) letters are on the whole more quickly formed than capital letters, and there is an enhanced measure of liaison between letters as the pen spells them into words. It is perhaps best not to omit the small, curved top member of g, remembering its origin. When the skeletal forms of the letters are followed and a nib-slant of 30° from the horizontal is maintained, the character of this alphabet remains consistent.

39. Basic Script minuscules. Example by William Gardner.

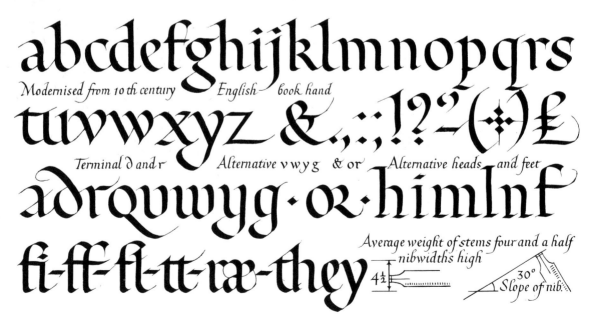

abcdefghijklmnopqrs

Modernised from 10 th century English book hand

tuvwxyz &.,:;!?²-()£

Terminal ∂ and r Alternative v w y g & or Alternative heads and feet

ɑ∂rquwyg · oʒ · himlnf

fi-ff-fl-tt-ræ-they

Average weight of stems four and a half nibwidths high

4½

30°
Slope of nib.

Ha uma diferença i ncrivel na impressão q ue oferece um texto auto grafado quando escrito em l inguas diferentes.As seis ling uas modernas do diagrama são muito semelhantes: utilizam o me smo alphabeto e derivam das mesma s origens. Assim, visualmente,a diferen ça entre elas e semelhante ao contras te que existe na sua sonoridade,q uando faladas.Estos diferentes impressões demonstram-se a travez da juxtaposicão das linguas numa serie de h exagonos baseados

Es gibt erstaunliche Unterschiede hinsicht lich des Eindruckes, den eun Texthervorwurf, wenn er in verschiedenen Sprachen üb ersetzt steht.Die sechs modernen Sprachen des Diagramms sind sich sehr ähnlich sie benützen dasselbe Al phabet und sind von demselben Ur sprüngen abgeleitet. Dennoch ist Unterschied zwischen ihnen si chtlich vergleichbar mit dem Kontrast zwischen ihren g esprochenen Akzenten. Diese verschiedenen Eindrücke lassen s

Intrycket man får av en skrift, gjord på olika språk,är otroligt skiftand e. De sex moderna språk,so m är upptagna i diagrammet h ar mycket gemensamt· såväl alp habetet som ursprunget.Dock är den synbara skillnaden dem emellan så gott som densamma som den hörbara mellan de olika accenter na.De olika intrycken kan påvi sas genom en uppställning av de olika språken i en se rie sexhörningar, baser ad på latinet + Intryc ket man får av en s

Si sententia eadem div ersis linguis expressa des cribitur, scripturae ipsius qu asi adfectio mirum quantum m utatur.In hac tabella,una senten tia sex linguis hodiernis descreb itur, quae alia alii simillimae sunt· e odem utuntur litterarum ordine, eod em a fonte derivantur, sed ut audient i sono sic specie differunt aspi cienti.Quantum varietur adfect io demonstratum est earum linguis verbis hexagonoru m serie continua dispo sitis, quibus septim

Il y a une grande dif férence dans l'impressi on donnée par l'écriture d es diverses langues.Les six langues du tableau sont semb lables:le même alphabète est util isé et les langues sont dérivées des même origines.Pourtant la différence visuelle se compare aux contrastes p erceptible des divers accents dans la langue parlée.Les impressions sont demonstrées par la jux taposition de ces langues dans une série d'hexago nes basée sur le Latin + Il y a une grande di

There is amazing dif ference between the im pressions which a script gives when it is written in d ifferent languages.The six mo dern languages in the diagram are very similar· they use the sam e alphabet and are derived from the same origins yet the difference bet ween them visually is similar to t he contrast between their acce nts when spoken.The diffenc e in impressions is shown by juxtaposing the lang uages in a series of he xagons based on Latin

C'è una differenza so prendente nell'impressi one che dà la stessa scrit tura in diverse lingue.Le sei lingue moderne del diagramma seguente sono molto simile. Ess e usano lo stesso alphabeto ed han no la stessa origine. Però la differenza visuale che esiste tra loro è simile al contrasto tra i vari accenti qua ndo queste lingue sono parlat e.Queste diverse impressio ni sono dimostrabili sovr apponendo le varie ling ue in una serie di esa goni basati sul latin

40. The visual flavour of European languages compared by Christopher Russell.

41. Commencement of *The Kumulipo*. Penmanship by William Gardner.

> **KUMULIPO – The Hawaiian Song of Creation**
> *Ka Wa Akahi – Chant One*
>
> O KE AU I KAHULI WELA KA HONUA
> At the time when the earth became hot
> O KE AU I KAHULI LOLE KA LANI At the
> time when the heavens turned about O KE
> AU I KUKA'IAKA KA LA At the time when
> the sun was darkened E HO'OMALAMALA
> MA I KA MALAMA To cause the moon to
> shine O KE AU O MAKALI'I KA PO The time
> of the rise of the Pleiades O KA WALEWALE

Assuming there are characteristics common to all styles of penmanship it is of interest to note in passing a variety of endemic differences between the visual flavours of several Continental languages. It might seem impertinent to do so were it not that foreigners have also characterized the English people and its language. And here in consistent penmanship is an experimental draft on this theme done in 1972 by Christopher Russell (40). Readers may also decide for themselves which, if any, of the seven languages depicted express the following national attributes: domination, sentimentality, arrogance, passivity, gentility, detachment, extroversion.

Many areas of the world have only recently taken the Roman alphabet into use. In earlier times communication remained unrecorded but certainly not unremembered, and was transmitted by word of mouth from generation to generation. In Hawaii, for instance, Polynesian history was the prerogative of the official Remembrancer, and their Creation Chant, the Kumulipo, is the equivalent of our Genesis story from the Bible. In this transcription by the author (41), modern Basic Script capital letters are used for the Hawaiian of Queen Liliuokalani in 1897, while minuscules express Martha Beckwith's standard work of translation into English in 1951. Alternating Hawaiian with English solves the problem of proceeding smoothly through such an epic and its translation, however different in length their respective phrases might be. Here, the Pacific constellations of the Southern Cross and the Pleiades burn through from the back of a text rich in vowels.

Blackletter

Blackletter styles evolved slowly from the earlier rounded writing of western Europe into a rapidly performed and condensed drill of strokes: a 'one-two-three' movement for straight letter stems—repeated three times for letter 𝔪, for example. The speed of the method, coupled with its capacity for cramming more letters on to a page made it a very economical one in terms of time and use of costly materials. Words were scarcely, if ever, composed of blackletter capital letters for reasons of legibility. Traditional examples follow, but below (42) the printers' best and richest version, refounded by Stephenson Blake and Company in the nineteenth century, has been put back for the sake of the exercise into penmanship; this particular effect depending on a nib angle of about 40° from the horizontal. The style is little used these days but can be a joy to the calligrapher. Sign-written blackletter is frequently seen contrived by means of a pointed brush, but a square-ended brush copying pen strokes produces a more authentic result.

One of the finest medieval blackletter manuscripts is the Metz Pontifical (43), written and illuminated in the early fourteenth century and now in the Fitzwilliam Museum, Cambridge. The writing is of an astonishingly controlled richness, letter stems and background forming a progression of equal black and white bands. The ends of ascenders and descenders are done with the pen's point and there are other sophistications, such as the shared stems in *hoc* and *tempore* of the second line.

At the time when arrangeable metal letters were first being assembled in Germany for the printing of books faster if not better than the scribes could perform, the aim was to reproduce the best

42. Blackletter. Example by William Gardner.

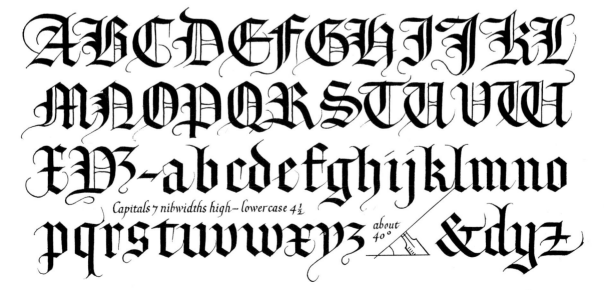

Capitals 7 nibwidths high – lowercase 4½ about 40°

43. The Metz Pontifical. Black-letter book-hand. Fitzwilliam Museum, Cambridge.

44. Printed Latin psalter by Fust and Schoeffer, 1457.

45. Monumental brass inscription. Morley Church, Derbyshire'

current styles of penmanship. This famous psalter (44) which issued from the press of Fust and Schoeffer at Mainz in 1457 claims in its bibliographical note to have been inscribed 'Without the use of pen'–'Look, no hands', as it were. Those craftsmen of the mid-fifteenth century who switched their skills to the engraving of letter-punches for typographic book production are believed to have been recruited largely from the goldsmiths and silversmiths, especially lettering artists in those and other metals. Gutenberg himself was not unfamiliar with the die-sinkers' contribution to the striking of coins since, according to Victor Scholderer, his father had been associated with the archiepiscopal mint at Mainz.

One of the largest craft fraternities using the blackletter style in metal was that of the commemorative artists. Figure 45 is from a finely inscribed memorial plate at Morley church, Derbyshire, engraved in 1403, only shortly before the Roman system of enumeration finally yielded to the Arabic.

46. Italian Rotunda manuscript, 15th century.

47. A page from the *Graduale Romanum*, Venice, 1499–1500.

The crisp and prickly styles of northern Europe, however, were not liked by the practitioners of the Mediterranean, and it was Italian penmen who first softened the blackletter form into a modified style called Rotunda (46).

48. Daily Telegraph masthead.

The Daily Telegraph

A 'humanized' blackletter was first brought into printed use by Schoeffer, Zainer, and others, but soon yielded to the Italianate round-hand, or Rotunda, style for theological, legal and scholastic printing in Italy, France, and even in Germany. Rotunda's richest maturity was achieved in Spain; but illustrated on the previous page (47) is a particularly fine example from the folio *Graduale Romanum*, edited by Franciscus de Brugis, and printed in Venice by Johannes Emericus de Spira in 1499–1500. It displays large freely cut initials in red, and is sprinkled with red Lombardic capitals throughout.

Present-day blackletter is restricted to little more than signwritten facias such as 'Ye Olde Tea Shoppe', the headings of legal documents such as 'Memorandum of Agreement', and the mastheads of a declining number of daily newspapers (48). Of Rotunda scarcely anything is now seen although it might well enjoy some revival in modified form.

8

Formal italic writing

Formal italic scripts have matured as working alphabets concurrently with, but quite independently of, cursive handwriting where the letters are joined up and the pen seldom leaves the writing surface except between words. Formal italic is arguably best used small: for notes in the margins of manuscript books, or for verse at appropriate sizes.

During his career Edward Johnston evolved for himself a sharpened formal italic alphabet of great effect. Its employment in this diploma, 1930–5, displays all the panache of the master penman, exquisitely engraved for printing by George Friend (49). The merging of curved stems, ye, ve, be, pa, oo, sc and wa, as well as a letter d which combines o and l, together with some very sparkly s's and y's at the ends of lines makes this an outstanding item from Johnston's legacy of styles.

49. Diploma of the Central School of Arts and Crafts by Edward Johnston and George T. Friend.

London County Council
Central School of Arts and Crafts
Whereas in the year 1 8 9 6 the London County
Council founded the Central School of Arts and
Crafts to provide education in the arts and crafts
and industries and to maintain and develop their
practice and Whereas the London County Council
established a Diploma of Fellowship of the School
to be a mark of distinction of past students who by
their practice have promoted the objects of the School
and Whereas the award of this Diploma has
been entrusted by the London County Council
to the Board of Studies of the Central School
We being members of the Board declare that
the Diploma of the London County Council
Central School of Arts and Crafts is hereby
awarded to

It is also a remarkable example of collaboration, since an engraver's precise interpretation of penmanship could no more expect entire success than the converse, more especially between masters of the two crafts. It took five years of engraving plate after plate to bring the work to this state, where a few hard-to-find but definite inconsistencies impossible to the pen are compensated by subtle refinements peculiar to the use of a graver.

Another great user of the sharpened formal italic alphabet was the scribe Mervyn C. Oliver whose well-known calligraphy evinced strongly held personal views on penmanship. The lines below (51) in Oliver's distinguished style comprise a dynamic example of the formal italic hand at work – assured, rapid, consistent, crisp. The letter stems are here outstandingly graceful with an unusual height of seven nib-widths.

The lines overleaf, commissioned by Joscelyne Charlewood-Turner, from a reflection by Rupert Brooke (52), were inscribed in 1967 by Dorothy Mahoney in a formal italic script of great authority. The nib slant of only some 20° from the horizontal imparts strength to the

50. Formal Italic Script. Example by William Gardner.

51. Sharpened formal italic hand of Mervyn C. Oliver, 1937.

52. Formal italic hand of Dorothy Mahoney.

If a man's being is rooted in one steadfast piece of earth which has nourished him and if he can on his side lend it glory à do it service it will be a friend to him forever.. and he has outflanked death in a way.

53. Sharpened formal italic hand of William Gardner.

Come live with me and be my Love, And we will all the pleasures prove That hills and valleys, dale and field, And all the craggy mountains yield There will we sit upon the rocks / A gown made of the finest wool / Thy silver dishes for thy meat And see the shepherds feed their flocks / Which from our pretty lambs we pull, / As precious as the gods do eat By shallow rivers to whose falls / Fair lined slippers for the cold / Shall on an ivory table be Melodious birds sing madrigals. / With buckles of the purest gold. / Prepared each day for thee and me

stems, and there is a markedly even progression of letters within words. It is satisfying to note the horizontal stroke shared between r and t of 'earth', the linkage of the first three letters in 'friend', the sparkling terminal r in 'forever', and the junction of f and l in 'out-flanked'. Although ligatures are in evidence throughout the writing, it is by no means a cursive hand.

Above is part of a draft in sharpened, formal italic hand for the rendering of Christopher Marlowe's sixteenth-century poem to a shepherdess (53). A nib slant of 50° or more from the horizontal is enhanced by the addition of a letter slant of 15° from the vertical which slims the stems and emphasizes their shoulders and feet. The initial letters to these lines seek affinity with styles of English vernacular manuscripts of pre-Marlowe times.

Johnston excepted, scribes with an interest in typography have succeeded less at typeface design than have typographers with calligraphic sympathies. The answer must lie in a familiarity with printing usage. Some might have reservations about a script typeface in that however penlike its letters may be, they will be appearing on the page in rigidly unchanging form with none of the subtle variation of living calligraphy. A solution to the problem of printing handwritten letterforms offers itself in the use of photo-litho facsimile, a facility widely available these days. This example (54) is from an anthology of Wordsworth's verse in formal italic book-hand. The fears poets have expressed that extroversion in penmanship could form a barrier to the communication of thoughts in verse are countered by readers' testimonies that a controlled and consistent live inscription adds a dimension to the act of reading.

Intimations of Immortality...

There was a time when meadow, grove, and stream, The earth, and every common sight, To me did seem Apparelled in celestial light, The glory and the freshness of a dream. It is not now as it hath been of yore;— Turn wheresoe'er I may, By night or day, The things which I have seen I now can see no more.

54. Italic book-hand of William Gardner from *A Wordsworth Treasury*. Shepheard-Walwyn, 1978.

Handwriting

With the spread of education in the fourteenth and fifteenth centuries came a consequent increase in private correspondence between those able to read and write. A rapidly executed handwriting in which the pen formed the letters into a flow of words, mostly without losing touch with the writing surface, had been evolved in Italy and taken into use by the literati of west-European countries. Left is a typical example of this style (55). It is from a woodcut of 1540 in the copybook of the writing master and teacher Giovanbattista Palatino, which was used to teach his mode of handwriting to people of taste and culture in the sixteenth century.

Following an interval of some three or more centuries, during which handwriting fashions had preferred the fine and sinuous copperplate style, discussed in the next chapter, and its 'Civil Service hand' descendant, there was a twinge of conscience among nineteenth-century educationalists that children should perhaps receive more thorough encouragement to improve their handwriting.

Mary Monika Bridges (wife of Poet Laureate Robert Bridges), Marion Richardson, and eventually Alfred Fairbank alerted those concerned to the advantages of legibility combined with efficiency, and a revival of the italic hand spread rapidly through the schools of the United Kingdom during the 1930s, maintaining its influence after the Second World War through the enthusiasm of a flourishing Society of Italic Handwriting, founded in 1951. T. Gourdie's *Improve Your Handwriting* (1975), from which figure 56 is taken, provides a practical guide to his Simple Modern Hand which is now, slightly modified, the official handwriting style for primary schools throughout Sweden.

This illustration (57) of the author's own handwriting shows a compromise between italic and copperplate forms.

It is of interest to examine in passing a few other examples of handwriting, which though not italic, are yet the everyday hands of those sensitive to considerations of the alphabet and with whom the author has been in correspondence.

55 (above). Palatino's copybook. 16th-century handwriting. Newbury Library, Chicago. Dover Press.

56 (below). T. Gourdie's Simple Modern Hand.

57. Handwriting of William Gardner.

58. Handwriting of Archie
Harradine.

59. Handwriting of Lloyd
Reynolds.

A. Harradine's style is patently a pleasure to write (58), and to read.
The letter-form bears very close examination, yet is not laboured in
the slightest. Capitals and minuscules associate perfectly and, though
this is in no way a running hand, there is a splendidly crisp and rhyth-
mical progression of letter stems, with complete mastery of word and
line spacing, plus a fine sense of texture and arrangement overall.
Occasionally a terminal letter is flourished, and in the case of the signa-
ture the initial also.

Nor is Lloyd Reynolds's handwriting over-concerned with ligatures
(59), yet it is obviously performed as rapidly as the pressure and enthu-
siasm of his message can be conveyed. One catches the urgency of the
writing itself and responds to both the underlining and the capitals of
the exclaimed word 'TEXT', in a situation where italics for emphasis
would be less effective.

Ralph Beyer, artist of the lettering in the new Coventry Cathedral,

60. Handwriting of Ralph Beyer.

Having worked with traditional Roman for many years
it was then my burning desire to break away from it and
do something in the way of freely-composed texts such
as had been done by Rudolf Koch in the 20's and
later on - though in a rather different spirit - by
David Jones. The inscriptions in the Catacombes of
Rome happened to be the subject of a picture-book
by my father which was published at just about that
time, and which inspired B.S. to initiate the translation inscriptions

* which I enclose.

61. Handwriting of Dorothy Mahoney.

I think that there should be a rapid improve-
ment in her work now that she is concentra-
ting on one subject only.

Anytime I can co-operate with you in any
work M.E. wishes to carry out I will do so
with pleasure,

Yours sincerely,

Dorothy Mahoney.

here favours an unstressed, monoline approach in his personal hand-
writing. In the letter (60) he gives the reasons for his breakaway from
conventional Roman style to one based purposely upon the early
Christian inscriptions in Rome. His father, Professor Oskar Beyer, was
a leading authority in the catacomb studies.

For sheer verve combined with individuality, Dorothy Mahoney's
handwriting is remarkable (61). It might at first glance seem thrown
around irresponsibly, but the apparently abandoned treatment of
letters is in fact under most expert and assured control. In appropriate
places words are linked by flourished terminations, while the swift
flow of penmanship within such words as 'rapid' and 'only' is good to
see. In the capital letter A is a startling and effective revival of uncial
form, and the construction of the E of 'M.E.' is also worth noting.

The copperplate style

During the sixteenth century at the two main centres of its manufacture, Flanders and Nuremberg, the standard of rolled copper sheeting improved to such an extent that its surface for the first time offered the same scope for lettering engravers as the penmen already enjoyed on parchment and paper.

This advance in engraving technology was to lead indirectly to a new style of handwriting for the penmen. The writing masters' copybooks had in the past been printed from wood-blocks cut to follow their original scripts (see figure 55); and so the versions copied tended to be influenced by the limitations of the wood-block as a medium for expressing the subtleties of handwriting. Rolled copper sheeting, which replaced the wood-block for this sort of work, had no such limitations; capable of taking fine strokes and ornate flourishes its potential was not slow to be exploited. The writing masters were free to adopt a less restrained approach which was in turn reflected in the work of those following the copybooks with the newly developed flexible-pointed pens.

The dramatic increase in literacy brought about by the introduction of moveable type meant that more and more people wanted to learn to write themselves. The writing masters exploited this new market for their skills by publishing instructional copperplate-style copybooks that were printed from metal plates, so propagating a handwriting method that is still occasionally used today.

It will be readily appreciated that the split-pointed pen and the signwriters' brush make wider and therefore heavier strokes under downward pressures (62). By the same token these instruments, if well made, spring back into a point, to produce very fine strokes when lightly

62. Copperplate Script. Example by William Gardner.

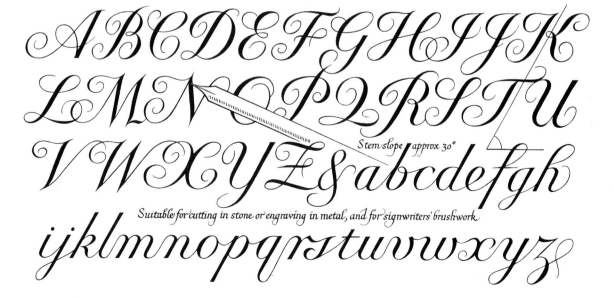

Stem slope approx 30°

Suitable for cutting in stone or engraving in metal, and for signwriters' brushwork.

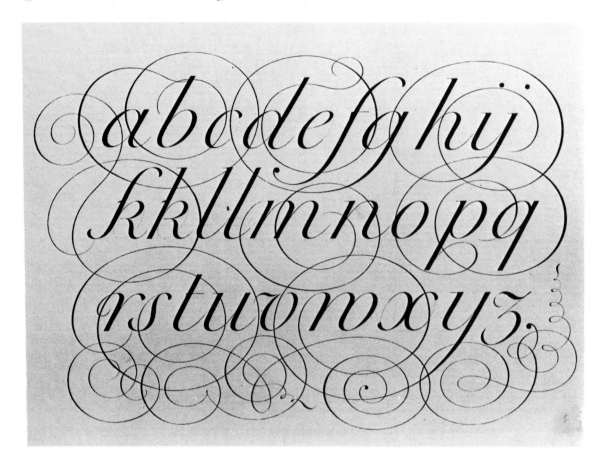

63. George Shelley's *Natural Writing*, 1709-14. State Art Library, Berlin.

trailed. The graver too, being of 'V' section, will similarly yield a heavy or a fine stroke according to the depth of entry into the metal plate.

The copperplate style of writing as evolved during the sixteenth and seventeenth centuries may be exemplified by page 5 of George Shelley's copybook (63), *Natural Writing* (London, 1709–14). Control is everything here, and the progress of all the flourishing is faultless. Certain of the letter-forms might not find universal favour today: w, for instance.

A splendid example of the copperplate style (64) is to be found in John Guillim's *Display of Heraldrie* (1724), at folio 75 of the section entitled 'On Precedency'. It is by an anonymous engraver, under an illustration of the royal arms of King George I. Faint guide lines were usually ruled on to the plate and burnished away after use. The slant of the stems is in the region of 40° from the vertical, with the flourishing modestly present. Although letter-forms and spacing here are rather freely interpreted, the engraving is most delicately done.

For sheer abandon combined with disciplined skill, however, one must return to such examples as Shelley's capital letter E (65) from

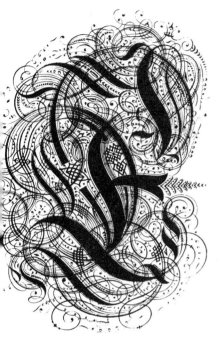

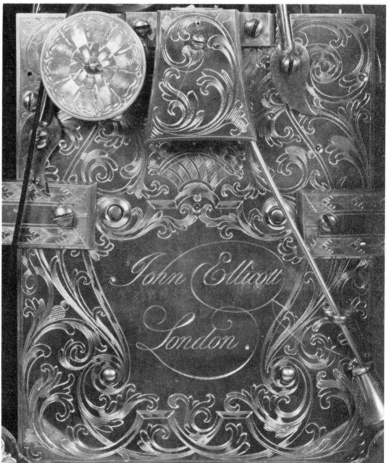

64 (above, right). From Guillim's *Display of Heraldrie*, 1724.

65 (above). Letter E from George Shelley's *Natural Writing*.

66 (right). Engraving on backplate of clock by John Ellicott, *c* 1670-1750. Victoria and Albert Museum.

page 27 of *Natural Writing*, already cited; it is almost 'Kell-ish' in its tortuous yet faultless convolutions. A much later and debased copperplate-style capital of the 'sprung-horsehair' school is illustrated in Chapter 16 (figure 131).

A great deal of lettering in the copperplate manner was engraved upon flagons, goblets and dishes of precious metals, and upon the back and front plates of seventeenth- and eighteenth-century timepieces. This example (66) is from the fine brass backplate of a bracket clock by John Ellicott (London, *c* 1670–1750) now in the Victoria and Albert

67. Victorian copperplate hand-
writing. Solicitor's document,
1876.

ABCDEFGH
IJKLMNOPQ
RSTUVW
XY&Z
abcdefghijklmnopqrstuv
œ wxyz œ
1234567890

68 (above). Typeface Marina by
Stephenson Blake, 1936.

69 (below). Typeface Youthline by
Stephenson Blake, 1952.

ABCDEFG
HIJKLMNO
PQRSTUV
WXY&Z
abcdefghijklmnopq
rstuvwxyz
1234567890

Museum. The flourishing of the name is modest, but beautifully carried through in harmony with the rich and accurate cutting of the decor.

It could be said that the copperplate handwriting style of the seventeenth and eighteenth centuries culminated with the publishing of George Bickham's extravaganza *The Universal Penman* in 1741, with its subtitle *Or, the Art of Writing Exemplified*. In this, Bickham engraves the illustrations of his own styles of work and those of other leading practitioners of the day 'With the friendly Assistance of Several of the Most Eminent Masters'. The majority of these examples are effusive but, having influenced the handwriting of those days, they continued to do so to a somewhat lesser degree throughout the nineteenth century down to the 'Civil Service hand' of the twentieth.

The above example of Victorian handwriting (67) is from a solicitor's document in which the pen moves sensitively along, with refined and delicate movements forming some very pleasant capital letters such as the D of 'Dresden'. Here it is clear that the copperplate style is at an advanced stage of its evolution.

In the typography of modern times a 'script face' is generally regarded as derived from copperplate styles rather than from those of formal scripts done with a square-ended working edge. R. S. Hutchings has described Stephenson Blake's typeface Marina Script (1936) as one of the hardest-worked alphabets of its kind (68). Its thin ligatures are designed to touch and join up when properly set. *The Encyclopaedia of Typefaces* (1962) points out that the founder's other heavier typeface script Youthline (1952) is designed to give an impression of continuity without the joining of its letters (69). Both Marina and Youthline are attractive faces in their own right, at a traditionally strong slant from the vertical.

Decorative flourishing

Swash letters and flourishes arose originally in penmanship from the occasional need to occupy vacant space, combined with high spirits on the part of the penman. The practice soon caught on in engraving too. Flourishing is something especially tempting to the scribe whether it is of letter ascenders and descenders, or of arabesque-like patterns. It is a challenge requiring confidence in one's skill and an overriding sense of follow through. With no yielding to hesitancy or corrective changes of direction *en route*, it can be a feat of impeccable navigation to speed through the intricacies of an interlacement and arrive where intended, apparently without effort.

A rich and prickly Gothic example of flourishing is the woodcut by Hieronymus Höltzel of Nuremberg (71) from his title page to a printed missal of 1517. Though in harmony with the splendid blackletter above it there is a degree of woodcut independence from the disciplines of pen-formed strokes in these flourishes.

In his 1530 exemplar (72), the writing master Giouanniantonio Tagliente demonstrated the possibilities in the art of flourishing. Such bravura is not of course the rule, and its effect soon depreciates when over-used. While Tagliente's four lines here are really more than enough, from each flourished letter looked at in isolation one may learn treatments for appropriate occasions.

A modern masterpiece of flourishing by the late wood-engraver Reynolds Stone is his letterheading for Stella Standard of New York (73), an early commission of c 1933. Here is only the slightest slant for an italic alphabet and the flourishing occupies perfectly the very

70. Swash characters and flourished stems selected by the author.

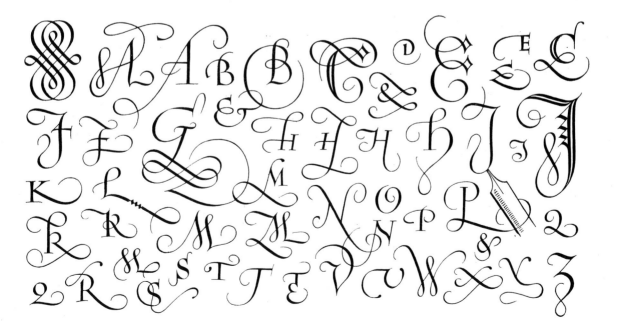

71 (right). Hieronymus Höltzel's flourishes. Wood cut, 1517.

72 (below, right). Tagliente's flourishes. Penmanship into woodcut, 1530. Newbury Library, Chicago. Dover Press.

73. Reynolds Stone's flourishes. Engraving on boxwood, c 1933.

74. Limited edition notice. Penmanship by William Gardner for the Holland Press, 1979.

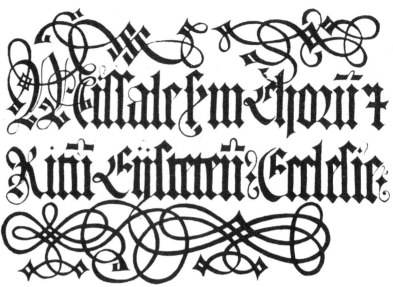

pleasant oval format. Reynolds Stone's earlier flourishing did not display the same consistency of stress as found in penmanship, since a mirrored symmetry was obviously felt to be more important to the composition; but later in the 1930s and certainly since then, the influence of pen-stress has featured in his work.

The calligraphy of a limited-edition notice by the author for the Holland Press (74) is styled for substantial photo-reduction, its thin strokes being thick enough to resist disappearance in the plate- or block-making, and its letter stems spaced perhaps a little more openly than they might be in other circumstances. The flourishing above the top line seeks to present an acceptable follow through for each of its convolutions and to enclose evenly balanced areas of background where they cross each other. l and d in the word 'published', though connected, are visually independent.

Arabic numerals

Prior to the partial adoption of Arabic numerals by West European countries during the fourteenth century, the Roman system of enumeration had long served. Its symbols are well known and remain valid especially for commemorative work, yet the simplicity of a figure such as 1888 compared with MDCCCLXXXVIII must be acknowledged.

Modern lettering artists have tended to say little about numerals. Even Edward Johnston in *Writing & Illuminating, & Lettering* (1906) only mentions in passing that '1 & 0 may be made on the line, 2, 4, 6, 8 ascending, and 3, 5, 7, 9 descending'. In fact 4 has nearly always been a descending numeral though the French would seem to have produced ascending 3 and 5 around 1800 and still sometimes adhere to this convention. In any case numerals rarely occur in alternately ascending and descending sequence. Much more often it would seem the designer is faced with imbalanced sequences such as 1677 or 1966 which produce a falling or a rising line of strokes rather than the less problematic level, ranging (neither ascending nor descending) one. The spacing of Arabic numerals should reflect that within any associated wording in the light of the discussion in Chapter 2.

The early printers went over to the Arabic system almost immediately, retaining the Roman for occasional use. George Painter has demonstrated how William Caxton commissioned his famous device from a woodcutter at Gouda in 1487, adapting his existing mercers' mark into a numerological pun (75). The mark has been interpreted as an interlaced 4 and 7. Read one way it gives the date of his obtaining Freedom of the Mercers' Company in 1447 and read the other it commemorates the issue of his first book in 1474 (Flanders dating).

Eric Gill's typeface Perpetua (76) is directly influenced by the earliest of the old-face numerals such as Bembo (1495), though the derivation of the completely tubular section of O is puzzling.

Probably the most characteristic breed of modern-face numerals originated from the Clarendon stable in 1845, where a need arose to equalize the height of numerals with accompanying text in capitals. A further revival occurred in Stephenson Blake's issue in 1956 of a type-

75 (above). William Caxton's device, 1487.

76 (right). Typeface Perpetua numerals by Eric Gill. Monotype, 1925.

1234567890

77 (below, right). Typeface Consort Light ranging numerals, 1956.

1234567890

78. American Bankers' Association numerals, 1958.

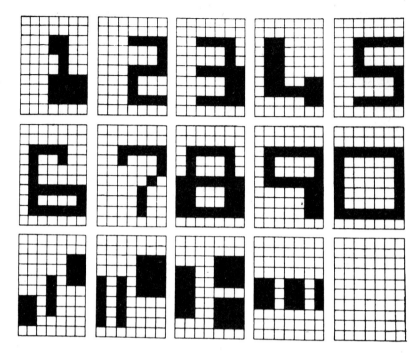

face (77) called Consort, which retains certain copperplate characteristics of two centuries earlier.

For some years – since 1958 – writers of cheques have become familiar with numerals designed for the American Bankers' Association (78), widely adopted elsewhere, and known as E 13 B. Such figures are scanned electronically and valued as specific proportions of a gridded area. Other systems have also been evolved, and electronic presentation of digits on watches and calculators has produced gridded forms readable enough in context but in some respects aside from tradition. Legibility enforces its own laws and we should look forward to seeing electronically formed numeral images of greater refinement as presentation techniques improve.

Minuscules: the scribe eclipsed

A whole millennium of penmanship had developed the national book-hands of western Europe to the point when a sudden retrospection by humanistic Italy in the fifteenth century rejected northern, angular Gothic styles as barbarous. The earlier reformation under Charlemagne of rounded letters was then readopted (79) at the very moment the printing-press ousted the scribe. True, there was an interim during which printers found their feet and scribes survived, but by the early sixteenth century, the new metal letter-forms had largely taken over except in liturgical and similar works, the German-speaking peoples alone retaining a love of blackletter. Since then the development of printed minuscules has very largely been out of the hands of penmen, italic excepted, and the practitioners of other crafts have contributed: punch-cutters, stone-cutters, brushworkers, and engravers in wood and metal. But Venice was the centre most concerned in the evolution of printed Roman-style lower case, with Nicolaus Jenson its most skilful exponent (80) there between 1470 and 1480.

It is not possible to include more than a very small selection from

79. Palatino's manuscript specimen book, c 1540. Bodleian Library, Oxford.

Vmq; reges expulsi vexarent Romani acerrimis bellis Antonius Posthumus litteris et armis doc tissimus fortiter et patrie amantissimus contra / mandatum patris sui sponte egressus à custodia, claustrorum hostes deuicit et conflixit magnum

80. Nicolaus Jenson. Lines from his presswork. Venice, 1470–80.

tis quindecim aureorg milibus noluisse parere:donec uxorem sibi ascitam misso diade mate eam reginam appellauit. Hæc diuturnis lachrymis atq; mœronbus tristé duxerat uitam:miseráq; suam fortunam deluserat. Execrabat mœsta uenustissimum pulchri tudinis suæ florem:qui superbum pro marito dominum pro regia atq; penatibus bar bará sibi custodiam ac prope carcerem comparasset:& relicta græcia ubi tot sibi splédi dissima fortunæ munera affluebát:pro speratis bonis inane quasi somnū suscepisset. Hæc itaq; Monima cum adueniens in Phernaciam Bacchides regiis mulieribus impe rasset:ut quod cuiq; facillimum & gratum esset:id sibi genus mortis eligerent: auulsū a capite diadema cum collo circumligasset misera se suspendit. Et cum corporis graui tate laqueus ille côfractus esset:O execrandum inquit diadema neq; in tam tristi mihi ministerio profuisti. Et cum super illud ab se detectum inspuisset:Bachidi côtinuo iu gulädam sese commisit . Veronica uero ueneni sibi paratum calicem cum eius matre quæ ueneni partem supplex orabat partita est . Et cum ex illo utraq; bibisset:debiliori profecto corpori & mala ætate confecto ueneni uirtus abunde suffecit. Veronicam au tem quia minusq; ad extinguendum satis fuerit hausisset:& uiuentem contorquebat uirens icendio sæuiens a Bacchide celere suffocata interiit. Ferunt etiā uirgines illas Mi tridatis sorores hausisse uenenū:Roxanā quidem iratam extremas fratri miserias fuis se imprecatā:Statiram uero nil crudele nil ignobile locutam fratrem summopere lau dasse : qp ille in tanto suæ uitæ discrimine haud sororum dignitate neglecta liberas eas atq; iuiolatas occumbere maluisset. His rebus apud Romanos nuntiatis Lucullus

81. Page-proof from Count Harry Kessler's Cranach Presse, Weimar, Germany.

And death's a weariness so over-charged
With incompletion, that we slowly come
To the conception of eternity.
Yet all the living fall into the error
Of over-sharp distinction. I have heard
That angels may themselves be unaware
Whether they move amongst the quick or dead.
The eternal current sweeps all ages on
Through both these realms, and dominates in both.

Do not belong to the Kessler Fount.

82. Typeface Albertus, lower case. Monotype, 1934–5.

abcdefghijklmn opqrstuvwxyz

countless examples of the minuscule alphabet, but these few twentieth-century examples may serve.

Following Edward Prince's death in 1923, George Friend inherited the responsibility for cutting the punches of Count Harry Kessler's private Cranach Presse at Weimar after the First World War. There had been a collaboration between Kessler, Johnston and Prince. Eventually Friend engaged in seven years of correspondence with Johnston about the work in progress, a story told by John Dreyfus in *Italic Quartet* (Cambridge, privately printed, 1966). George Friend himself indicates upon part of a proof page (81) four Ts and a Y, set in error, which do not belong to the Kessler fount. The Johnston touch is conspicuous in initial I of the fifth line.

The lower case of Dr. Wolpe's typeface Albertus (82) of 1934–5 is as satisfying as its capitals. Ascenders and descenders are usefully short and everything is crisply angular except for the dots over i and j which are unexpectedly round, and substantially greater than stem width. v and w are stressed in a traditional manner but the stress of y is reversed, maybe for the strength of its back. There is a delightful sparkle where sharpnesses meet in a, b, d, g, h, m, n, p, q and r, especially in letter g.

83. Typeface Perpetua, lower case. Monotype, 1925.

abcdefghijklmno pqrstuvwxyz

84. Typeface Times New Roman, lower case. Monotype, 1931–2.

abcdefghijklmno pqrstuvwxyz

The lower-case letters of Eric Gill's Perpetua, published by the Monotype Corporation in 1925, accompanied the capitals illustrated and discussed in Chapter 3. These letters (83) are strongly chisel-form, so that it is a surprise to find round dots over the i and j where an angular shape – square, lozenge or triangle – might be expected.

In the lower case of Stanley Morison's Times New Roman typeface (84), made generally available by the Monotype Corporation in 1932, similar characteristics are in evidence as feature in his capitals of this face shown and discussed in Chapter 3: the parallel-sided stems, and the 'blob' terminations of a, c, f, j, r and y matching that of capital J.

A more recent typeface is Monotype Corporation's Octavian (85),

85. Typeface Octavian. Monotype.

'Monotype' OCTAVIAN, as its name suggests, owes much of its character to classical inscriptional letters. Its designers, Will Carter and David Kindersley are both letter carvers and, in Mr. Carter's words they "set out to preserve in their alphabets all the essentials of their historic antecedents, at the same time feeling free to permit themselves an appropriate degree of personal drawing. While the ultimate authority is the ancient inscriptional pattern, the special characteristics of the present rendering are manifest in the economic proportions of the shapes and the modified relations of the strokes. Thus, the letters are narrower than the classical forms and their weight heavier."

IN MEMORY OF PHYLLIS BOTTOME
(Mrs Forbes Dennis)
BORN 1882~DIED 1963
"He prayeth best who loveth best
All things both great and small"

86 (above). Memorial tablet in
oxidized and gilt brass by
William Gardner and George T.
Friend.

87 (below). Memorial tablet in
oxidized and gilt brass by William
Gardner and George T. Friend.
Wittersham Parish Church.

In Loving Memory
of the Reverend Canon
W. E. WATSON
A.K.C. Rural Dean
South Lympne Deanery.
Rector of this Parish
1926—1949
Called to rest
15 March 1949
This tablet is placed here
by his widow & daughters

88. Memorial Stone at Bedgebury
Park School, Kent, by Michael
Renton, 1978.

a collaboration between David Kindersley and Will Carter, both of
Cambridge. Its letter-form and internal spacing are very much in
harmony, yet not slavishly, with the Roman inscriptional formula. The
first stroke of letter y bulges very slightly outwards, presumably to
counteract the vacuum which follows in the wake of such letters as r
and t, as seen in lines 2 and 3 respectively.

Designed by the author and engraved in George Friend's work-
shops, the incised panel opposite (86) is of brass, subsequently oxidized
to a dark charcoal colour. The capitals, ranging numerals, lower case,
flourished italics, and moulded border are gilt. Another collaboration
by the same designer and engraver employed similar material and
techniques for the Watson tablet (87), in Wittersham parish church,
Kent.

By Michael Renton, the above inscription (88) cut in York stone
displays an italic of minimal slant which agrees well with the capitals of
two sizes, lower case, and Arabic numerals. The two finely flourished
letters lend personality to this incised commemoration which was cut
for Bedgebury Park School, Kent.

In the letters overleaf (89) carved in sandalwood and Nigerian
walnut, Will Carter uses a gentle letter slant with sensitive spacing.
Letter y is something of a cross between a tailed lower-case u and a
tailed v, and it displays an affinity with the y of the Octavian typeface
just seen. The v's and w's have unusual in-turned terminal stems. Liga-
tures are absent throughout, yet the words flow smoothly and with
clarity.

…and I said to the man who stood at the gate of the year, 'Give me a light that I may tread safely into the unknown.' And he replied, 'Go out into the darkness, and put your hand into the hand of God. That shall be to you better than light, and safer than a known way.'

89 (top). Anonymous quotation. Carved wood by Will Carter, 1964.

90 (above, left). Leathersellers' Company Christmas and New Year greetings card by William Gardner.

91 (right). Anglo-Austrian Society plaque. Signwriting by Kenneth Breese.

abcdefghijklmno
pqrstuvwxyz &

Suitable for engraved or painted work, heavier or lighter as required Slope of Italics variable, here 20°

abcdefghijklmnop
qrstuvwxyz&for

92. Minuscules to go with Roman and italic capitals. Example by William Gardner.

Hot-stamped in gold foil upon a shaped, red ground, the block for this Christmas and New Year greetings card of The Leathersellers' Company (90) was derived photographically from a black-and-white line drawing by the author in italic minuscules at a 15° slant from the vertical. The impression is deep enough to ensure a sparkle of light from the edges of the letters and from the Company's armorial bearings.

The signwriting from the studio of A. & K. Breese (91) combines italic capitals and lower case with Arabic numerals in a composition which most agreeably occupies the plaque, including some modest flourishing above and below. The brushwork might claim a calligraphic mode not least in the E of 'SOCIETY' and the B of 'Britain'.

The first alphabet (92, above) is based upon forms which retain their validity for commemorative inscriptions in stone and metal, as well as for brushwork. A traditional italic (92, below) offers a closed *a*, and a *g* like a tailed *a*; the slant of its stems not being so little as to raise doubts about its italic status nor so great as to make the letters appear to be falling forwards.

Figure 93 overleaf is a commemoration in the style of the lower alphabet in figure 92. It was designed and cut in Westmorland green slate with some slender flourishing and ranging numerals.

We are rightly advised to cross our t's. We have also seen how blackletter obliged i to adopt a distinguishing mark among so many similar

93. Memorial cut in Westmorland slate by William Gardner. Walton Parish Church, Buckinghamshire.

stems. But i needed no such mark before blackletter, and after that style fell into disuse, to dot i's became merely a thoughtless habit; the author has frequently omitted them from commemorative work without them ever being missed. In fact, in most instances words without dots are perfectly legible, more restful, and much less like the measles. Compare **indivisibility** with **ındıvısıbılıty**. The 'norm' for minuscules or lower-case letters is dependent upon purpose, tools, skills, materials, scale, conditions of visibility, training, taste and the nature of patronage.

On a point of typography, the text of this book is set in Eric Gill's Sans Light, and it has been claimed for this face that it is far and away the most visually comprehensible of all the sanserif alphabets; for those who appreciate arrangement, looser rather than tighter letter-spacing is the obvious preference.

Specialized work

It is time now to turn to the special tasks the alphabet is asked to perform for us today. It would be impossible to cover each area thoroughly in a book of this size so the following chapters have been constructed in the form of a 'guided dip', the intention being to show a wide range of lettering styles and usage, and to stimulate fresh interest in the myriad letters that we see every day.

Packaging

In many ways the 1950s was a stimulating time for point-of-sale lettering studios whose services were greatly in demand. The first example (94), showing some of the products of just one supplier, illustrates the vast overall range of insistent brand names which shoppers were invited to purchase, something which the changeover from grocers' shelves to supermarkets, and televised advertisements has enhanced still further; the alphabet was bludgeoned into hard labour as never before. The Twining tea-packet logo (95) shows how, with a little imagination, letter-form can be used to echo the shape of the product being advertised.

Neon

Glass tubes containing neon or other inert gasses which glow when

94 (right). Package and container lettering. Unilever products.

95 (above). Twining tea-packet logo.

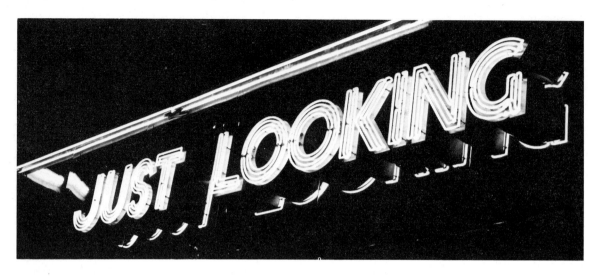

96. Neon lettering on a shop in Knightsbridge, London.

activated by high-voltage electricity have been in use for at least half a century. Ways were soon found to form monoline letters and to use them for identification and advertisement on shop facias (96) and upon the sides of industrial buildings. Whatever may have been attempted towards classical letter-form in this field, the fact remains that glass tube cannot readily be bent into sharp angular forms without interfering with the electric charge internally, and a neon alphabet tends therefore to be one of rounded angles – from **A E F L M N V W Z** into A E F L M N V W Z. Much more attention has been paid in recent years to the architectural integration of illuminated signs, and the design options have been analysed exhaustively.

It will be appreciated that, subject to say a standard 10 ft (3.05 m) length of glass tubing, larger monoline letters could present less angular difficulty than smaller ones, but there are other design complications, including the problem of electrical circuitry.

Alphabets for the blind

Although Louis Braille's system, created in 1829–34, of dots in various touchable arrangements is the one now universally used, it should not be forgotten that several other systems were attempted in the nineteenth century. J. Alston's in 1836 consisted of plain Roman capital letters cast and presented in relief for tactile recognition. A modified system by W. Moon, 1847, went further. In this, reading was by recognition of strokes peculiar to individual letters of the alphabet, ⟨ for K or ⊃ for D, the stems common to so many being omitted.

It is a pity Alston's system has not survived to the present day,

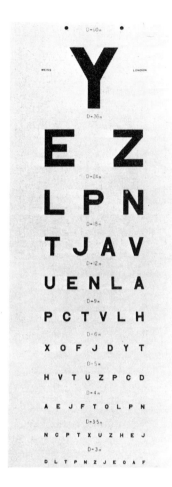

97 (above). Visual acuity test card. Weiss.

98. An accidental double impression from a wax stencil.

because it would seem capable of refinements impossible in the others. Extra-sensitive touch could surely learn to distinguish between styles of alphabet suited to different ends: sanserif for plain statements, the elegance of copperplate, or italic for poetry.

Visual acuity

It was the Dutchman Herman Snellen who in 1862 was the first to introduce some scientific standardization into the measurement of visual acuity. Derivatives of Snellen's types, now used almost universally for sight-testing, consist of a sequence of capital letters of the alphabet in diminishing sizes (97). Sanserif letters were chosen for their easy readability, their forms fitting a rectangle, the height of which is five times the thickness of the letter stems, and the width four times. As in other situations, the wider letters M and W refuse to conform and so remain conspicuously absent. The stem thickness of the first letter at the top of the test card, so the formula goes, subtends a visual angle of 1 minute of arc when viewed at 60 metres distant, while those in the subsequent lines of letters do so at 36, 24, 18, 12, 9, 6, 5, 4, $3\frac{1}{2}$ and 3 metres respectively. What this means is that if, for instance, at 6 metres the sixth line of letters can be read correctly, the sight is normal. Test cards are of course obtainable printed in reverse for viewing by reflection at a distance of 3 metres from a mirror where consulting-room space cannot manage a 6-metre view.

It is well known that the eye can be misled by unexpected or false visual evidence. The accidental double print, below, from a typewritten wax stencil (98) suggests binocular misalignment or inability to focus – even migraine. A poster on such lines could lead to a rush on the druggists for a corrective.

Photographic reproduction

The development of photographic letter-reproduction techniques has been the twentieth century's main contribution, so far, to the science of printing. It is divided into two fields: photolettering, which is the creation and arrangement of individual letters, generally for headings and display purposes; and photosetting – keyboard-operated setting of continuous lines of text.

Photolettering

By the 1930s photolettering was gaining ground in the U.S.A. By 1960 the catalogue of the Reinhold Publishing Corporation of New York

1584a **Graceful Design**

1584n **Graceful Design**

1584c **Graceful Design**

1584n 15° **Graceful Design**

99. Photolettering treatments. Cloister Black. Reinhold Publishing Company.

entitled 'Alphabet Thesaurus' could demonstrate that photolettering provided its users with a choice of over 3,000 alphabets comprising 'an audition of graphic voices, cultured, coarse, vigorous, severe, moody, spirited, boisterous, subdued, mellow, harsh'. These alphabets, the work of 120 talented lettering artists, could be modified through the use of the septagonal reproportioning lens which reproduced the master letter at any size, positive or negative, reversed, expanded, condensed, inclined forwards or backwards. An optical technique called 'circoflair' enabled lines of words to perform all manner of convolutions: to arch or dip, in fan or plumb curves, in arch-dip or dip-arch, fan or plumb ogee. Further lens treatments could contrive perspective and 'elastaflex' effects in which words assumed top-converging form, tapered to the right or left in various combinations, arched, dipped or ogee. Strong perspective effects gained greater legibility from the gradual proportional increase of letter space towards the remoter ends of lines, while shading and outlining of letters, even the appearance of bas-relief could be extracted photographically from a line drawing. A marginal note in the catalogue points out that obliquing an alphabet by such optical means can impart a mood of velocity to it and open up virtually unexplored territory. A good example of this (99) is No. 1584 on page 609 of the catalogue, where the Old English style Cloister Black is expanded, condensed and italicized at a slant of 15°.

Photosetting

We have already touched on the prospect of optical letter-spacing in computer-assisted photosetting in Chapter 2 and only need reminding that the supremacy of hot-metal letterpress is over. Keyboard composition can now assemble a stream of letter images on film. On the printed page these photographically derived letter-forms never match the aesthetic excellence of the inked impression left by their hot-metal counterparts, but they are cheaper and easier to produce, use and store. Spacing and justification are now largely automatic, the operators having no opportunity for further refinements; but there is a substantial qualitative difference between the products of differently designed photocomposition equipment. The choice of system, therefore, is crucial, and here the typographic designer's familiarity with printing technology can assist in appropriate and tasteful presentation of words on the page. Ultimately, though, responsibility for good spacing now lies with the system designers in a situation where taste is balanced against cost.

Extreme photo-reduction of handlettering or typesetting sometimes produces a situation where printing ink risks jumping into the

100. Eric Gill's Sans Ultra Bold plus an example showing internal areas filled in.

ABCDEFGHIJ KLMNOPQRS TUVWXYZ& ABCDE

enclosed areas of such letters as A, B, P and R, and a, b, c, d, e, g, o, p and q to render them 'blind'. For lettering, A can remain legible at tiny sizes if its bar is lowered; even rendered as a solid triangle it will be legible in context and on its own. M and W are also readily recognizable when blind: **M W**. How blind can an alphabet be without losing validity? Above are the first five upper-case letters from Eric Gill's Sans Ultra Bold (100) with internal areas obliterated entirely. Readers might like to complete the treatment of this alphabet and compose words with the result. Trouble may be anticipated in distinguishing silhouettes of letters such as I, E and H.

The typewriter

The early history of the typewriter cannot be examined in any detail here, but since the 1950s we have been offered a significantly wider choice of alphabet styles. Originally, typewriter styles of the nineteenth century tended to be restricted to what might be described as Egyptian or Antique faces, and the end product was an unevenly spaced sequence of letters. An overcondensed m occupied the same width of metal type head as a normal n or an overextended i, and was accepted as a mechanical necessity called 'standard spacing'. A welcome development was the move towards a proportional arrangement of letters within words, which meant that m, n and i were literally given their head, no more, no less, to produce a rhythmical stem flow. Equally beneficial was an increased range of face styles to suit the nature of the work—even 'handwritten' ones for personalized communication.

What you say about the Baltea typeface is, of course,
quite true. I feel myself that one or two clever touches
(such as the omission of the middle serif in the 'm' and
the overlapping in the 'W' that you mentioned) have im-
proved the position, but basically the old question of
the typeface on a standard spacing typewriter remains:
the wider letters always look cramped, and the narrower
letters impossibly elongated. This raises the whole
problem of standard and proportional spacing typewriters –
a problem which, unfortunately, is not solved by the mere
fact that proportionally spaced type is better and more
attractive than standard spaced type.

101 (above). Typewriter style
Baltea. Olivetti.

102 (right). Typewriter style
Modern. IBM.

The even impression and crisp char-
acters of the Executive make it ideal
for the preparation of high-quality
masters for offset lithography, while
proportional spacing makes it possible
by means of a second typing to justify,
that is, to make the right-hand margin
straight. The typescript can also be
reduced in size photographically.

But the introduction of these proportionally spaced typewriters
revealed some inherent diffficulties: the different sizes of heads re-
quired slower type-bar action if key clash were to be avoided, and
this mitigated against higher typing speeds. A typewriter face such as
the elegant Baltea (101), as designed by Giovanni Pintori for British
Olivetti, attempts with success to alleviate certain of the pressures of
spacing through ingenious letter design.

Figure 102 shows 10pt. Modern which is featured as IBM's general-
purpose type for the company's Executive machine. Justification of
the words 'high-quality' serves to emphasize the narrow measure
of the column. Though named Modern here, it has strong Venetian
attributes, and a prestigious appearance for general correspondence.

In recent years there have been important technological innova-
tions in electric-typewriter design—the introduction of exchangeable
'golfball' heads, for example, which give the keyboard operator a
wide selection of founts for use on one machine—but the develop-
ments have been made in the application of existing alphabets rather
than in actual typeface design.

The alphabet used in crafts

Architecture

Buildings have always presented opportunities for the display of edicts and aphorisms—from inscriptions on the triumphal arches of ancient Rome to the presidential sayings on the buildings at Washington, D.C. The words may be few and emotional, a prayer perhaps, or they may be massed into a texture decorative in itself yet containing a readable message.

Ralph Beyer's lettering in the new Coventry Cathedral springs immediately to mind. Beyer's motives for his choice of alphabetic style have already been discussed in Chapter 9. The eight Tablets of the Word, in widths ranging from 14 to 16 ft (4.27 to 4.88 m), were incised in capital letters evolved for that specific situation. Ralph Beyer may be quoted again here.

In designing these panels I was given full encouragement and authority to turn to the first Christian inscriptions for inspiration, to the expression of their faith in primitive form—unspoilt and yet exceedingly subtle. . . . Though the handwriting of the catacombs formed a basis for my work, no new work can rely completely on inspiration from examples of the past without arriving at best at a clever pastiche. The source of inspiration of a work of art is of little importance if it does not succeed in its own right. I was therefore concerned to an equal degree to evolve letter-forms and symbols in the language of the art of this century.

The illustration of one of the tablets (103) shows the manner in which stones are set together and inscribed with letters 12 in (30.5 cm) or more high. Architect Sir Basil Spence desired that the letters 'should be "felt", some irregular, some smaller than others, but each one a piece of incised sculpture in its own right.' Indeed they are, and have an arresting power quite remote from conventional Roman letter-cutting.

103. A Tablet of the Word by Ralph Beyer. Coventry Cathedral.

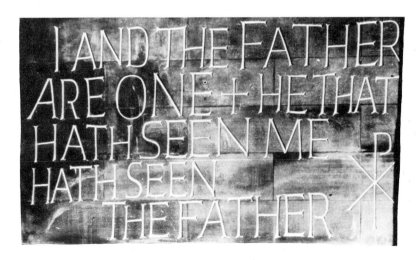

104. Martin's Bank, Wigmore Street, façade. Ernö Goldfinger.

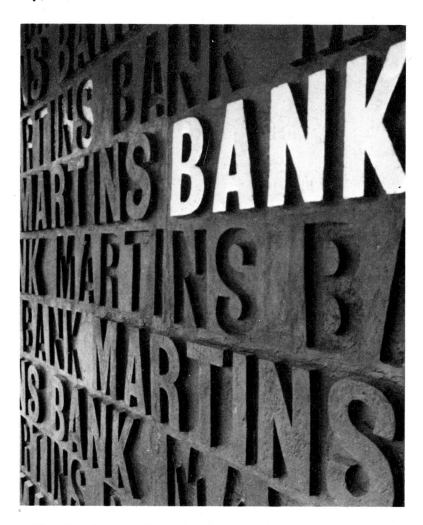

Not all architectural lettering, however, is monumental in mood. This eye-catching façade at the Wigmore Street branch of Martin's Bank, London, by Ernö Goldfinger (104) is of cast concrete sanserif capital letters about 12in (30.5cm) high, partly in relief and partly incuse (sunken), with the name picked out in gold. It is an impressively rich example of textural use of the alphabet.

Interior commemorative work, though sometimes also large in scale, is generally more intimate. Kevin Cribb is seen opposite (105) in the early stages of inscribing a slate panel to the memory of Peter Howard, for the foyer of the Westminster Theatre, London. As usual, the words are set out on the surface before cutting begins. Slate, being relatively soft, is a beautiful material in which to form letters, having a fine, virtually grainless texture free of shells, nodules and other hazards. When complete, the name PETER HOWARD was gilded, and the two sizes of italics left in their natural cut state.

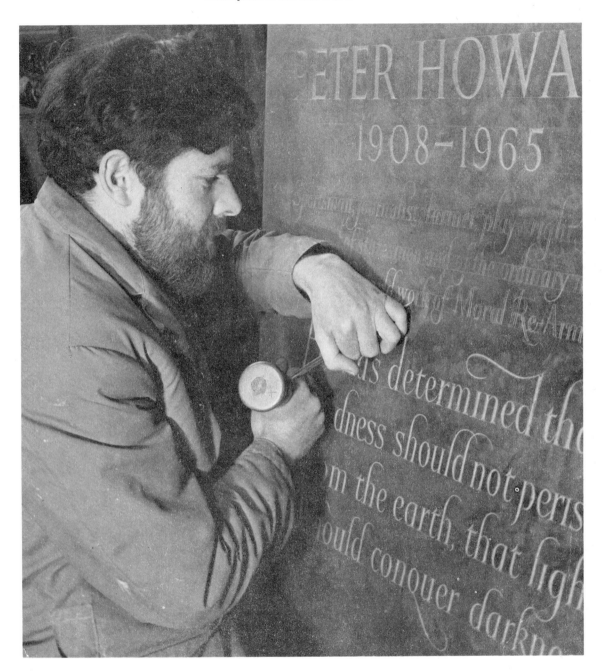

105. Memorial to Peter Howard. Westminster Theatre, London, by William Gardner and Kevin Cribb.

Glass-engraving

The two goblets engraved by Christopher Russell (106, overleaf) demonstrate a merry-go-round of words passing and repassing on the glass. One is engraved in capital letters, the other in minuscule italics.

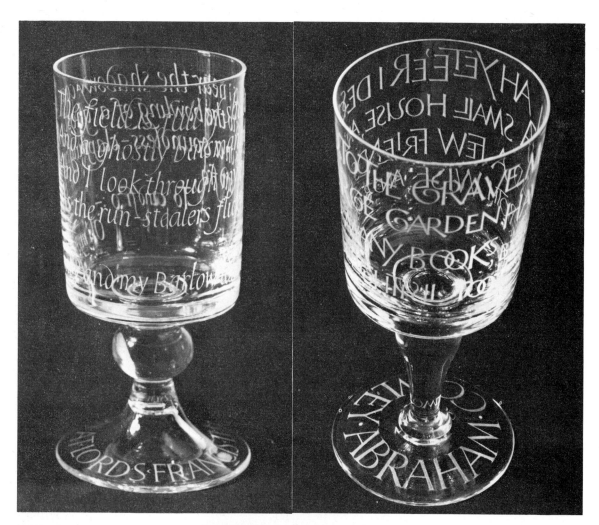

106 (above). Rickman goblet and
Cowley goblet. Glass-engraving
by Christopher Russell.

107 (right). Brodrick memorial
window. Playden Church,
Sussex, by William Gardner and
Christopher Russell.

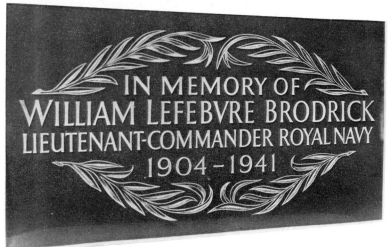

The finished effect is evocative of lace but there is an added third dimension and sparkle. Unless you are accustomed to the mirror-world of the printer, the remote sides of the goblets are not easily read: the Abraham Cowley theme (right) is one of small houses, friends, garden and books. The Francis Rickman thoughts (left) are of cricket at Lords, full fields, ghostly bats and run-stealing. It is all very well to know one's letter-form and spacing in two dimensions, but where the slippery glass curves away from the diamond point into a third dimension, far stricter control is required. The foot of each goblet bears carefully packed names in a tight curve, and we shall return to this problem later, but to engrave upon a shallow cone poses yet another physical consideration.

For windows, engraved plain glass may be used instead of the traditional stained and painted work. The panel opposite (107) forms the commemorative part of a window at Playden, Sussex, and is a collaboration between the author and the glass-engraver Christopher Russell. This alphabet is similar in style to Medallic Roman used on coins and medals, and being at the base of the window, stands out as a planned lacy texture against the dark evergreen trees of the churchyard outside.

Textiles

With lettering upon a square-based grid, canvas for instance, although there should be no difficulty with E, F, H, I, L and T, the curves, and especially the obliques, found in the rest of the alphabet cause severe problems.

Leaving aside such classic models of needleworked lettering as St. Cuthbert's stole (Durham, 909–16) and the Bayeux Tapestry (c 1077), an excellent example of the difficulties when a square-gridded alphabet attempts to follow a curve is the fragment of an Elizabethan woollen-pile carpet, overleaf (108), where the letters of the Garter motto struggle gallantly in a virtually impossible situation.

Lavinia Shanks, aged seven, demonstrates in her sampler of 1826 the kind of needleworking skill expected of little girls of those days (109). The challenge usually included alphabets of capitals and minuscule letters as well as Arabic numerals, interspersed with border patterns reminiscent of printers' fleurons (flower-shaped ornaments). In these three alphabets Q consists of a reversed letter P.

Capital letters of anything approaching Roman proportions cannot really be done at a stem height of less than five units. Shown on page 75 is an alphabet of cross-stitched capitals (110) worked as closely to the Roman formula as a five-unit-high stem will allow, together with a

108. Fragment of Elizabethan woollen-pile carpet. Victoria and Albert Museum.

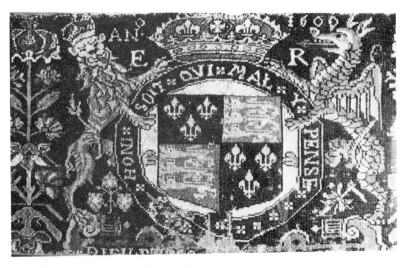

109. Needleworked sampler by Lavinia Shanks, 1826.

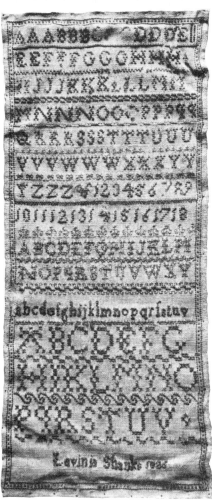

110 (above) and 111 (below). Canvas-worked alphabet of capitals with ranging numerals by William and Joan Gardner.

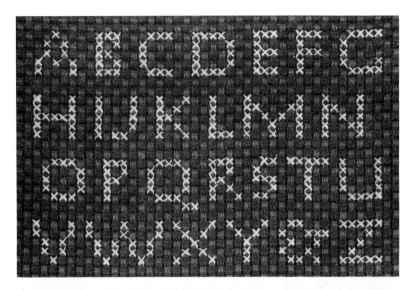

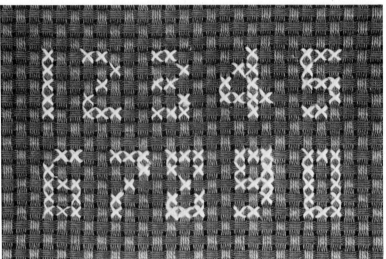

ranging set of Arabic numerals (111). There is room for variation in letter-form even within such stringent limits, and some might prefer a width of four units rather than five for the letters C, D, G, H, N, O, Q, U and Z. An odd number of units means that the horizontal members of E and H may be centralized but the greater the number of units the better may diagonals be placed and curves contrived.

There is no end to the diversification of letter-form in modern embroidery. But overleaf are two machined examples by Pat Russell: the first is stitching in a light-toned thread on a dark cloth (112), being part of the motto from the arms of the University of Oxford, 'Dominus illuminatio mea'. The second, quilted upon foam-backed velvet to

112. Machined embroidery by Pat Russell. From text of Oxford University Press device.

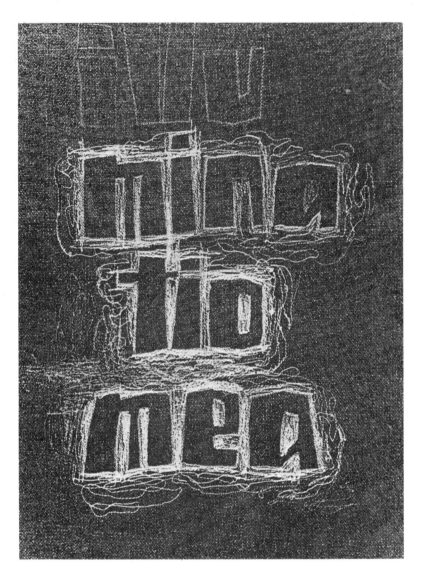

obtain the requisite depth of shadow (113), is a quotation from Hamlet, machined freely in a square-letter form.

By way of contrast and uninhibited by grids or any other consideration, it is of interest to see Thérèse de Dillmont's woodcut illustration of capital letter W (114), stated to have been taken from a sixteenth-century decorative alphabet by Giouanniantonio Tagliente. The woodcut here depicts soutache or applied braid, and although Tagliente's alphabet in fact omitted the W, he would surely have been pleased with its attribution *en suite* with the rest and so well executed.

113 (right) Machine-quilted extract by Pat Russell, from *Hamlet*.

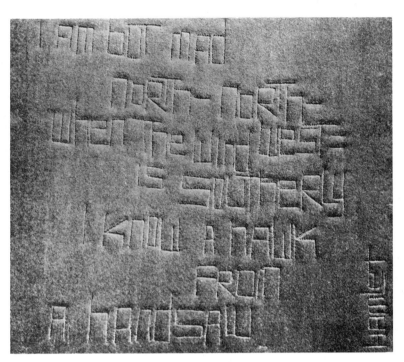

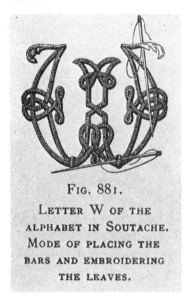

Fig. 881.

Letter W of the alphabet in Soutache. Mode of placing the bars and embroidering the leaves.

114. Wood-cut capital letter of soutache. Dillmont's *Encyclopaedia of Needlework*. N.D.

Calligraphy

This craft is no longer restricted to elegant work in black upon a white surface, enhanced by, say, a heading of coloured capitals. Of contemporary professional letterers, Ann Hechle has given notable thought to the emotional expression of words in prose and verse. As she points out, poetic mastery is conveyed through the sound of words, a sensory rather than an intellectual quality which must be listened to like music. The poem then exists on two levels which become fused, but in trying to do this with the pen or brush it must do so in visual terms so that it is perceived through the eyes as through the ears. The weight, colour, tone, and shape of letters can all be used to portray the ebb and flow, range and cadence of the human voice, as well as to characterize the qualities of the words themselves.

The first verse of an ancient dance-song (115, overleaf) has been subtly interpreted in her calligraphy. The ditty itself is very much older than its first published appearance in the seventeenth century. The lines of the verse are lettered in green with tones varied to the sounds of the words, and the refrain 'dilly-dilly' is in dark blue, with the small glossed notes in black. Quill pens were used, on vellum.

115. Calligraphy by Ann Hechle.

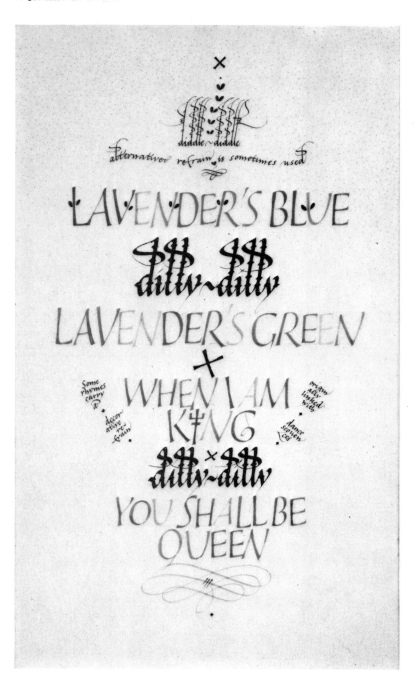

Bookbinding

The conception of a two-dimensional letter-form converted into three may be seen in figure 116. It is from the upper case commissioned by

116. The Fell Alphabet lit from two angles. Bodleian Library, Oxford, and Roger Powell.

117. Slim alphabet of capital letters. Bookbinding by Roger Powell.

Bishop John Fell, as designed and cut for printing purposes in the Oxford University Press during the latter part of the seventeenth century. Here the letters were redrawn by Sheila Waters, reversed (voided) for block-making, and then fitted into the design and decoration of a distinguished commemorative binding by Roger Powell for the Bodleian Library. From this one impression, low-angle lighting from eleven o'clock and from five o'clock in turn provide an alphabet in relief or incuse respectively, an incidental effect of which Sheila Waters is likely to have been cognizant, but which John Fell may never perhaps have envisaged.

Above (117) the alphabet is treated in a highly subjective manner. The words 'SAIL ON O SHIP OF STATE! SAIL ON' are tooled in gold upon the leather. Elongated letter stems set close together provide an attractive banded pattern to the partial concealment of the message. The letters themselves are admirably disciplined. Openings of the

ABCD ABCD
EFGHIJ EFGHIJ
KLMNO KLMNO
PQRSTU PQRSTU
VWXYZ VWXYZ

118. Medallic Roman alphabet by William Gardner.

119. Obverse of I.I.S.I. silver medallion by William Gardner.

four Ss, the diagonal of N, the minimal top of T, and the exclamation mark, all seem to give the right answer, enhanced by fleurons which sparkle from within the letters—in all, a further example of adventurous treatment of the alphabet from Roger Powell's bindery.

Circular-format lettering

Alphabets for the circumscriptions of coins must be readable at tiny sizes, and to add to the design problems, the permitted relief of a coin is extremely low. Furthermore, letters with very delicate serifs may lose them after some years' wear in circulation. An explicit style of alphabet, therefore, without serifs yet perhaps not without grace, was evolved by the author for his personal use. This Medallic Roman (118) seems to satisfy the above requirements and, as the differently lit photographs of the one engraving show, may be in relief or incised.

A 'V' section used in relief is seen in this obverse of the silver medal awarded by the International Iron and Steel Institute (119). For an example of use where the apex of the relief has been flattened, the obverse of the current Cyprus coinage is shown (120).

Though not perhaps for coins, a companion minuscule alphabet may be required to accompany the Medallic Roman style, and figure 121 attempts a matching simplicity. It is openly and rhythmically spaced, and avoids dotted letter i. The illustration is from one of a series of

120 (above). Obverse of current coinage of the Republic of Cyprus, by William Gardner.

121 (right). Italic minuscule alphabet to accompany Medallic Roman. William Gardner.

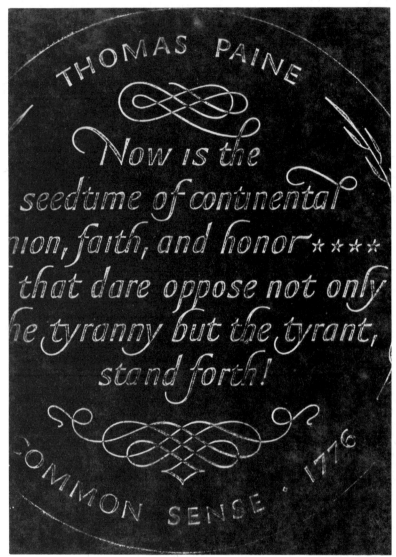

silver medallion reverse designs by the author for American Express Inc.

Lettering around a coin is not too much of a strain on its spacing but a tighter curve can raise considerable problems. John Skelton with carved Roman capital letters (122) shows the way in a fine cylindrical commemorative stone. There is no weakening of letter-form anywhere, but a degree of deference to the circular arrangement is revealed very delicately, in letter N in JONES.

Michael Renton's letterhead for B. J. Denyer, the musical-instrument maker, as engraved upon the end grain of boxwood (123) displays a sensitivity for curves which are tighter in some places than others.

122. Cylindrical stone memorial by John Skelton.

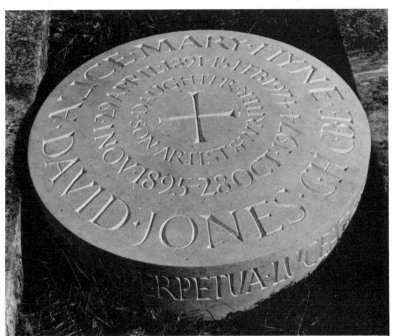

123. Denyer letterhead. Engraving on boxwood by Michael Renton.

124. Mixed-curve scroll with lettering by William Gardner. City of London arms, Old Bailey.

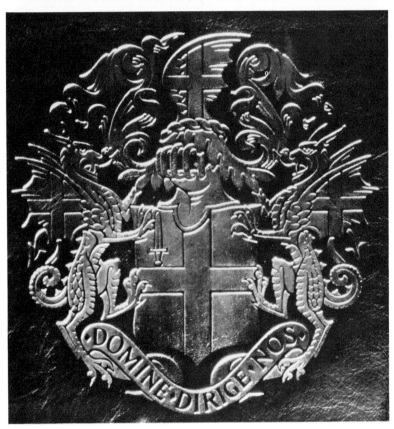

The gold-stamped arms of the City of London (124) show another example of the waisted sanserif letter-form in the mixed curve of a scroll. A brass block made from the author's drawing is hot-pressed in gold upon the backs of the green leather upholstered chairs used by High Court judges at the Old Bailey.

Alphabet at play

Over the years there have been many books available to children which amusingly associate letters of the alphabet with the names of animals to be found in the zoo. Creatures which peer through and climb around the alphabetically ordered capital letters do so in the cause of identification and spelling. For Alligator, Bear and Camel there may well be alternatives but the animal associated with Z is almost invariably the same. With very few exceptions, typographic

125. Soup alphabet, in pasta.

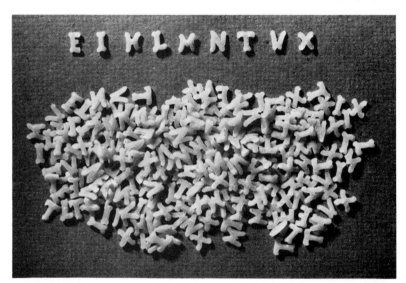

126. Alphabet sweets.

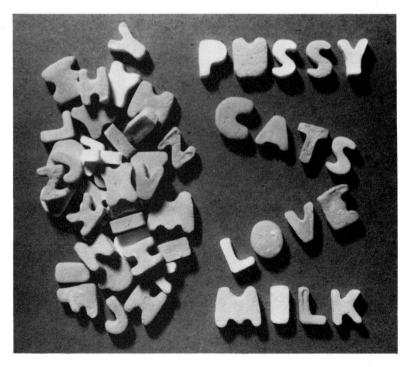

letters were not designed to excite the imagination of children and there is certainly room for adventure. A select minority of artists, however, have come to terms with the alphabet, and taken pleasure in exploiting the letters, mostly capitals: Monika Beisner, for instance, in *Monika Beisner's ABC* (1979), has created a charming pictorial alphabet actually composed of the animals and objects associated with the letters.

Capital letters stamped out of pasta (125) are a well-known delight to children when sprinkled into the soup. In the smaller sizes there is naturally a tendency towards simplification, and open letters with straight stems predominate. As in stencilled letters one anticipates a problem over the insides of A, B, D, O, P, Q and R – even C, G, and S – where enclosures or near-enclosures might tend to remain blind.

Countless parents have blessed the manufacturers of alphabet sweets (126). Such letters in pale colours may not perhaps satisfy any aesthetic criteria, but even a $\frac{1}{4}$ lb 'fount' enables both simple and multi-syllabic words to be spelled out, which if correctly done may be crammed into the mouth as a reward; their educational counterparts of coloured plastic offer less inducement.

As pattern

The alphabet has also been used skilfully to produce patterns pleasing in their own right. Of countless examples three will be sufficient here. First, a Jaeger carrier bag (127) on which the letters are assembled into a texture where the words accept their place as pattern in shades of brown. The company logo can still be read but its function in this

127. Carrier bag. Jaeger.

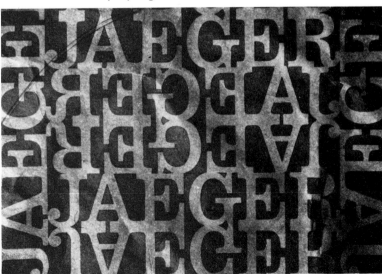

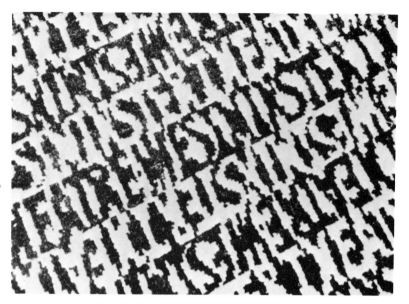

128 (above, left). Paper bag.
Victoria and Albert Museum shop

129 (above, right). Westminster
Theatre floor carpet by John and
Sylvia Reid.

130 (right). Envelope lining
pattern. Lloyd's Bank Limited.

design is primarily decorative. The second is a bag from the Victoria
and Albert Museum shop (128). The two Caslon italic initials combine
splendidly with surely the finest typographic ampersand of all time;
it is a delightful design. As a third example, the somewhat condensed
capital letters used here for a floor carpeting (129) are literally tex-
tural. The words 'WESTMINSTER THEATRE' are counterchanged in
pairs of lines and then reversed. Letter-form is casually angled upon
the grid and the result appropriately softened by the pile. Architects
John and Sylvia Reid were responsible for this and for the theatre as a
whole.

Photo-tangled characters are frequently used as a printed lining for

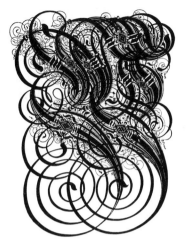

131 (above). Initial letter W by Paulus Franck. Nuremberg, 1601.

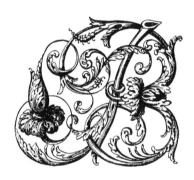

132 (above). Initial letter B by Manoel de Andrade. Lisbon, 1719.

133 (above, right). Subjective alphabets. Dover Press.

134 (below, right). Jumpy Latin by Edward Benguiat.

NECKTIE STRIPED

STATIC

SLAPSTICK

TRANQUILIZERS

BENGUIAT series of jumpy latins v

envelopes, and effectively prevent their contents from being read while sealed up. The weave pattern of numerals opposite (130) is employed by Lloyd's Bank and forms an intriguing texture.

Affectation

One may draw a clear distinction between what Laurence Irving has so rightly condemned as 'the affectation of imperfection' which belittles the aim for perfection itself as pointless and time-consuming, and an integrity by which the very best is aimed at within the options available. This distinction applies not least to the presentation of the alphabet and we may tread on delicate ground unless we know or can guess the motivation.

Was Paulus Franck of Nuremberg serious when he engraved initial letters such as the W illustrated above (131) at the start of the seventeenth century? Probably he was. Did Manoel de Andrade of Lisbon in 1719 have his tongue in his cheek when he produced letters such as the B shown here (132)? Unlikely. For both it may have been just the natural outlet for their particular skills. The same question cannot be asked of S. C. Norton's Nervous style, or of Dan Solo's typefaces Necktie Striped, Static and Slapstick as illustrated (133), since they are intentionally intriguing, even outrageous. Jumpy Latin, designed by Edward Benguiat, forms a restless typeface too (134).

IF iT HAD NOT BEEN FOR THES
I MIGHT HAVE LIVE OUT MY L
ING AT STREET CORNERS TO
ING MEN. I MIGHT HAVE D
MARKED, UNKNOWN A FAILURE
WE ARE NOT A FAILURE. THI!
CAREER AND OUR TRIUMPH. NE
OUR FULL LIFE COULD WE HC
DO SUCH WORK FOR TOLERA!
JOOSTICE, FOR MAN'S ONDER!
OF MAN AS NOW WE DO BY A

135 (above). Ben Shahn's
alphabet of capitals, unlettered
letters. Cory, Adams and Mackay.

136 (right). Walter Crane's
'pseudo-script'. Bell, 1896.

Lo! infant Thought & Art, Man's children fair
First tottering from the cave, his primal lair;
Babes in the world's wood wandering to & fro,
To touch man's sordid heart & lift his care

The veteran letterer Ben Shahn did not develop the style of capital letters illustrated here (135) through any lack of knowledge of form. They are what he had observed as the amateur or folk alphabet of ' "unlettered letters" which violate every rule, every principle, every law of form or taste that may have required centuries for its formation.' Their appearance is intentionally pictorial, slower to read than print and thus more serious and more arresting in their impact. They have to that extent an affinity with the early Christian folk alphabets of the catacombs at Rome which, although having no particular graces, inspired Ralph Beyer to powerful effect in the new Coventry Cathedral (page 69).

It is impossible to tell whether Victorian illustrator Walter Crane was serious when he wrote what Edward Strange described as 'an interesting specimen of a pseudo-script' (136). Crane's lettered title pages and designs of a similar kind seem consistently naïve and com-

The love of the poets is a ting apart

137 and 138. 'New bug's' hand-
writing and embryo italic hand by
Ronald Searle. Max Parrish, 1954.

pletely at odds with the mature conviction of the drawings which accompany them.

One of the most pleasing of all extant alphabetic eccentricities from the Victorian era was dreamt up by Crane's contemporaries of the Vegetarian Society. In their address to Her Majesty Queen Victoria on her Golden Jubilee in 1887, they felt obliged, in their cause, to avoid the use of parchment or vellum. Appropriately and upon a good quality paper, the heading of the document was composed from letters made of carrots, leeks, asparagus, celery and other stemmed vege-tables – to excellent effect!

As to allegedly unreadable medical prescriptions, these may per-haps claim dispensation on grounds of security.

Contrivance

The handwriting of the 'new bug' at St. Custards School, Nigel Moles-worth, in _How to Be Topp_ (1954), was riotously contrived by Ronald Searle (137), and in Chapter 2 of the same book is his illustration of Nigel's attempt towards the acquiring of an italic hand (138). Such deliberate imperfection demands the highest degree of skill to perform convincingly.

Ralph Steadman's heading for the journal of the Society of Industrial Artists and Designers, _Designer_ (139), and that of its newsletter _Extra!_ (140) are by no means as casual or as fraught as they seem but are contrived through a mixture of professional skill and momentary abandon, the second impossible without the first.

A design which conveys the effect of heavily inked impressions upon roughish paper (141) was devised by Barnhart Brothers and Spindler in the late 1890s called Fifteenth Century, and subsequently renamed Caslon Antique by American Typefounders.

A few years ago the calligrapher and typographer Hermann Zapf tackled the challenge of designing a typeface for Stempel of Frankfurt for photocomposition in situations requiring the depiction of hand-

139 and 140. 'Designer' and 'Extra!' by Ralph Steadman. S.I.A.D.

141. Typeface Caslon Antique. American Typefounders.

ABCDEFGHIJKLMNOPQRSTUVWXYZ

142. Typeface Noris Script by
Hermann Zapf. Stempel.

The appearance of a typeface is something complex

ABCDEFGHIJKL
MNOPQRSTUVWXYZ
1234567890
abcdefghijklmnop
rstuvwxyz
ff ft ch ck ll nd qu ß &

143. Typeface Klang. Monotype,
1955.

ABCDEFGHIJ
KLMNOPQRS
TUVWXYZ&

abcdefghijklmn
opqrstuvwxyz

writing. An example is given here (142). Named Noris Script, it is
surely as close as one may get to informal handwriting in a typeface.
Looking carefully at it one can see the problems of liaison between

ABCDEFGHIJKLMNOPQR STUVXYZW 1234567890

144. Typeface Augustea Open. Nebiolo, 1951.

145. Typeface Futura Black. Bauer, 1927.

letters brilliantly solved, as well as the apparently casual dropping of the lower-case terminal strokes of h, m, n, s and u to achieve relaxation by design.

Derived adventurously from formal italic penmanship, Will Carter's stressed sanserif typeface Klang (143) was designed for Monotype in 1955. Its stems are distinctly waisted, their terminations slightly hollowed to avoid the illusion of bulging, and the thin strokes are strengthened to cope with the wear and tear of hot-metal type and inking problems. It is as notable for its directness of forms as Berthold Wolpe's Albertus, and is similarly vindicated in its popularity. Other faces which are calligraphically based include Warren Chappell's Lydian for American Typefounders, 1938, and Adrian Frutiger's Ondine for Deberny and Peignot, 1954.

Of those faces which simulate the Roman lapidary alphabet, Augustea Open would probably receive highest marks (144). It was designed by A. Butti and A. Novarese for Società Nebiolo, 1951, and evokes the effects of letters incised in stone seen in bright sunlight from the left and containing crisp shadows in its 'chisel-cut' stems. Other typefaces have been similarly designed: Castellar, for example, which we have seen on page 20 with its sunlight notionally from the right.

Futura Black, designed by Paul Renner for the Bauer Typefoundry, is the most sophisticated version of the stencil styles (145). Obviously there must be bridges of material between the insides and outsides of stencil letters possessing enclosures, notably O but also B, D, P, Q and R. Without such bridges the insides of stencil letters would fall out, and Renner has contrived successfully to satisfy all the requirements at once: consistency of letter-weight throughout, a high degree of legibility and admirable bridging disguised most effectively as diagonal stress in letters A, M, N, V, W, X and Y, with O stressed vertically. His lower-case alphabet and the numerals are no less ingenious and dignified.

Festivity

Two examples of alphabets designed with a sense of occasion and in a mood of celebration may be illustrated at this point.

146. Typeface Festival by Phillip Boydell and others. Monotype, 1951.

ABCDEFGHIJKL
MNOPQRSTU
VWXYZ&

147. Typeface Calypso by Roger Excoffon. Olive, 1958.

ABCDEFGHIJLMNOPQRSTUI
VWXYZABCDEFGHIJLMNO

The first is a typeface of capitals designed by Philip Boydell and his colleagues at the London Press Exchange (146) to commemorate the Festival of Britain in 1951. Issued by Monotype, it is based upon condensed sanserif upper-case italic containing a crisp and lively contrast of black and white. Relief or incuse is here a matter of choice, with some letters – K, O and R for example – unclear in this respect. Festival, as the face was named, was indeed festive, and novel.

The second face is Calypso (147), designed by Roger Excoffon for Fonderie Olive, 1958. It is one of the most ingenious alphabets, conjured from pieces of screened material, turning rhythmically this way and that, and incredibly readable in view of its three-dimensional convolutions. It has a powerful stamp of gaiety and movement.

Pliability

It is appropriate here to glance at stylized employment of the alphabet, harnessed by design studios in the cause of advertising, one of the best known examples having been the Scottie composed of the letters SPRATTS (148). Performance Cars Ltd. of Brentford in London display regularly their accomplished logo in the pages of *Motor Sport* magazine (149), and it will be noticed how letters have been cunningly manipulated to reveal not only the silhouette of a sportscar but the contours of its bodywork also.

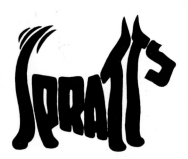

148. Spratts logo.

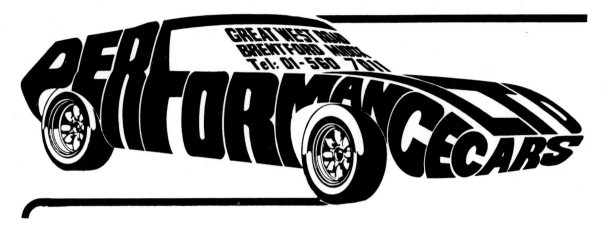

149. Logo, Performance Cars.

A further example of how biddable is the alphabet may be seen in this lively representation for the rock musical *Your Own Thing* (150): a good illustration of many such.

150. Lettering, *Your Own Thing*.

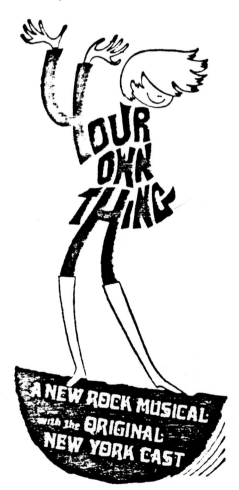

151. Christmas card by Norman
Ball, 1951.

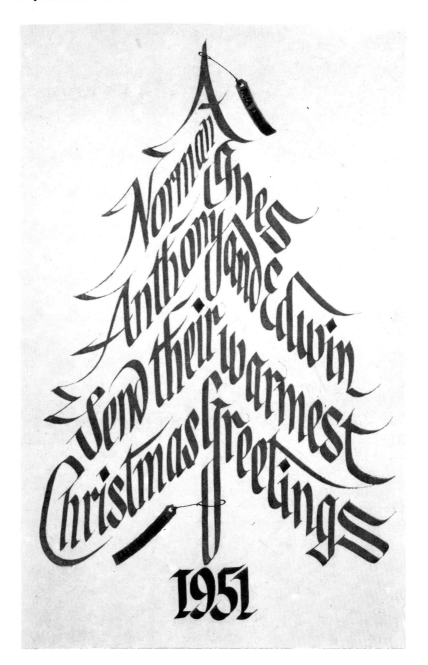

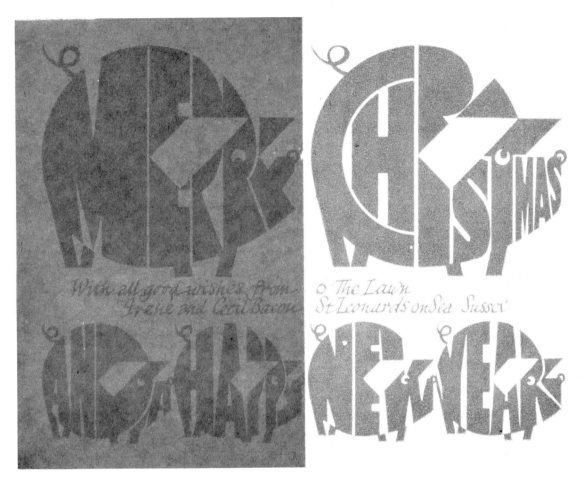

152. Christmas card by Cecil
Bacon.

In addition to the massive output of over a century's published
Christmas cards, an incalculable number have been privately produced
for circles of friends by artists and designers. Obviously few beyond
recipients can enjoy them, but the Christmas tree of Norman Ball
(151) is a classic among calligraphers; while these delightful porkers
(152) of the Bacon family come from a category of pliable alphabets
discussed immediately below. An exhibition of private cards employ-
ing lettering in this and similar ways could prove a revelation indeed.

Burlesque

Letters of the alphabet may be assembled in ways which evoke familiar
images and which ring a bell in a manner totally unconnected with

either the communication of thought as defined by David Diringer (page xvi) or as projected by Ann Hechle (page 77). The chief exponent of burlesque lettering is Paul Sellers of sophisticated *Wordles* fame, and this elementary sequence (153) echoes his theme. No explanation or comment is needed beyond the suggestion that sanserif, while entirely appropriate in these examples, may in fact not be the only letter style to have humorous visual potential of this kind.

153. Alphabet and mime by William Gardner.

L E A P · R U N · TRio · PLOD ON .. HALT !.

CROCODILE
CROCODILE

Fantasy

The alphabet may unwittingly seize the imagination at any age. In Chapters 55 and 56 of Rabelais's *Gargantua and Pantagruel* (c 1535) there is reference to words which, no sooner spoken, had frozen and congealed on the chill air without ever having been heard. Presently, however, Pantagruel, having found some of these unthawed, flung whole handfuls of them on to the ship's decks. They looked like sugar plums of various colours – red, green, blue, black, gold – and when warmed between the hands, melted like snow to become audible again.

Another equally unusual vision of the alphabet was recounted by someone of the author's acquaintance who clearly envisages the letters standing out against a dark background. A, B, C, D, E, F, G and H proceed steadily until I, J, K and L when they become obscure; followed by M and N, clear again but in a narrow place. O, P, Q and R crowd into a small and intimate corner of a childhood garden, while S, T, U and V march onwards against a bank which then merges into a solid hedge as a backdrop to W, X, Y and Z. The alphabet then ends at a pathway into which the letters slip through either of their own accord or when summoned to work in the world of words.

And few letters can have been summoned to work with greater effect than those which constitute the Almighty's mural message as

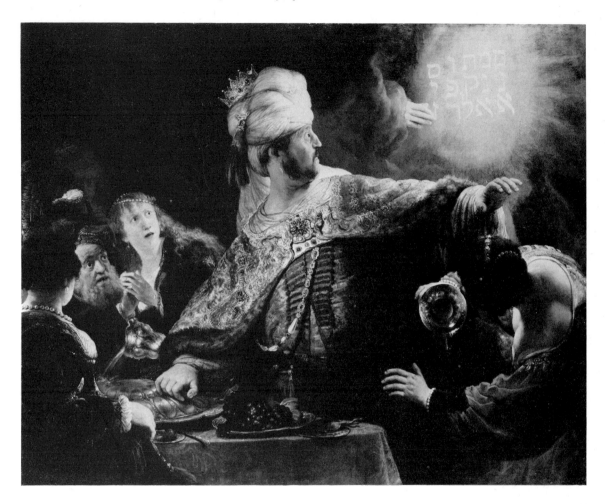

154. *Belshazzar's Feast* by Rembrandt, c 1635. 66 × 82 in (1.68 × 2.09 m).

portrayed in Rembrandt's *Belshazzar's Feast* (154). No professional Jewish *sofer* (scribe) could possibly approve such a woolly rendering of the elegant, square Hebrew characters; they would have been better shaped had the painter been as *au fait* with the pen as with the brush. Brush representations of penwork, as we have noted when discussing blackletter, rarely look authentic. Nevertheless this example makes a suitably dramatic finale to this survey of past and present alphabetic usage. It is time now to look into the future and assess the fears articulated by some that for the Roman alphabet the writing is already on the wall.

The Roman alphabet redundant?

We have examined a cross-section of uses to which the alphabet has been put during two millennia. It has been a sampling, with several significant areas left virtually untouched: the all-embracing field of books, magazines, newspapers, educational publishing, advertising material and posters for every conceivable end; the ingenious and accomplished animation of lettering for television; the hundreds of thousands of documents in the national historic and legal archives of London's Public Record Office; and the vast collections, among others both public and private, at the Victoria and Albert Museum, and British Library.

There exist over 1,000 styles of typographic alphabet to choose from, of which the majority have variants of at least Light and Bold in both their Roman and italic forms; and all come in several sizes. Enough, perhaps, has been touched on to show that the Roman alphabet has been harnessed, exploited, and dragooned in ways which would surely have strained the credulity of a literate Roman. Where, one may well ask, do we go from here? Those seventy alphabetists, typographers, and lettering practitioners who attended the Congress of the *Association Typographique Internationale* at Copenhagen in 1973 were challenged to debate the theme of 'Education in the Design of Letter-Forms' on the following propositions:

It can now be argued that henceforth any living tradition in handwriting in the West is bound to become extinct . . . that never again will a current hand be accepted for a standard book type . . . that the typewriter has doomed documentary penmanship . . . that individual handwriting has lost all behavioural pattern and lacks a suitable script model . . . that Edward Johnston and the Trajan alphabet have ceased to dominate the design of inscriptional lettering.

What should teachers now exemplify? For what reason? And who should have the authority to decide? As might be expected there was a voluble response from the floor, yet the solutions offered in discussion seemed less than conclusive. Paul Standard, the distinguished American calligrapher, has expressed the view that it will need a decade to discover and another decade to formulate new teaching policies, so that we may not see them in operation until the year 2000.

The fact is that we are entering a phase in which the importance of communication is increasing as rapidly as the microchip technology which is opening up its frontiers. Electronic gridding now contrives the design of text typefaces as well as alphabets and numerals intended for electronic recognition such as the Epps-Evans face (155) – produced by the Computer Science Division of the National Physical Laboratory – which has no diagonals or curves, echoing the dignity of square Kufic characters in Islamic calligraphy. There is talk of developing typeset-

155. Epps-Evans typeface for electronic recognition.

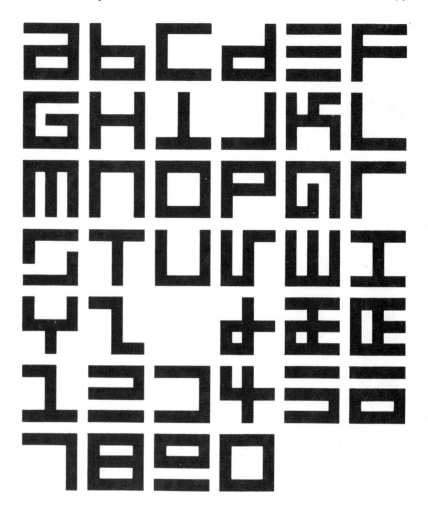

ting without keyboard, programmed by the voice. Where will it lead? dictation into print; from print into spoken word? Whatever happens by the end of the century we can be certain that the Roman alphabet will retain its place on the grounds of intellectual and aesthetic satisfaction, and its proven ability to perform successfully the huge range of tasks to which it is applied. Although handwriting may well find some substitute other than the typewriter, it too will retain its appeal for personal messages. As to letter-forms and their arrangement generally, it would not be the first time that in confused and degenerate circumstances some retrospective exercise has been called for and borne fruit – bearing in mind the salutary changes wrought by Charlemagne, the Italian Renaissance and William Morris. And with increasing freedom from restraint there are encouraging signs that design students have already begun an enterprising and uninhibited re-exploration of the alphabet. First-year work at London's Central

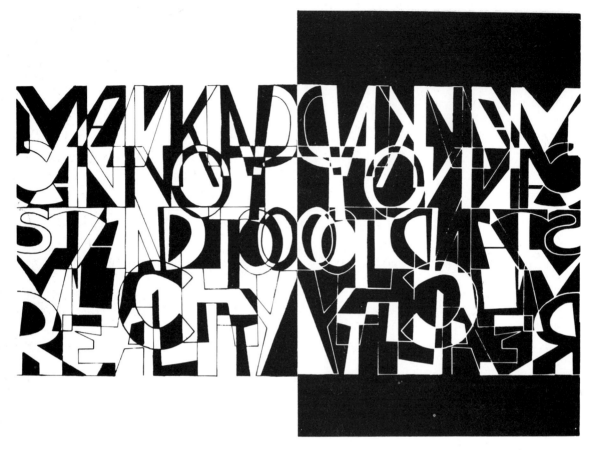

156. Central School of Art and Design. First year experimental work on the alphabet.

School of Art and Design (156) links study of essential basic history with freestyle structure of set texts, and goes much further graphically than just the spelling out of words. To achieve the best results from such exercises, as von Larisch advocated in Vienna at the turn of the century, readability may yield to other considerations in the course of experimentation. As long as the purpose of such investigation is to produce as the end result a readable alphabet that really works, there could surely be no more stimulating and valuable way of probing the options.

Bibliography

Of the many works consulted by the author the following selective list is offered. Any such choice is bound to be subjective, and an asterisk appears against those items considered especially relevant to the theme as a whole. All works mentioned are fully illustrated with photographs and diagrams, and the following titles which leave nothing to be desired in this respect are unreservedly recommended: Degering's *Lettering*, Diringer's *The Alphabet*, Alexander's *A Survey of Manuscripts*, Ogg's *Three Classics of Italian Calligraphy*, Bickham's *The Universal Penman*, Johnston's renowned and indispensable *Writing & Illuminating, & Lettering*, Morison and Day's *The Typographic Book*, and *The Encyclopaedia of Type Faces* from Blandford Press.

Emil Hübner's great work is now a rarity, but this as well as the publications of the Palaeographical Society and of the New Palaeographical Society, along with those of the Type Facsimile Society, may be examined at the Victoria and Albert Museum Library, and British Library. Morison's *Politics and Script*, Thompson's *An Introduction . . .* and Fairbank's *A Book of Scripts* all span calligraphic chronology, while Morison and Day, and Updike do the same for printing history. E. Strange deals with calligraphy, lettering and print to 1895, while Nesbitt illustrates decorative initial letters from their beginnings to 1959, and the Spencer/Forbes collection may be referred to also.

Classical and medieval

*Alexander, J. J. (Ed.) *A Survey of Manuscripts Illuminated in the British Isles*, Vols 1–6, Harvey Miller, London from 1978.

Boase, T. S. R. (Ed.) *The Oxford History of English Art*, Vols II, III and IV, Oxford from 1957.

Catich, Edward M. *Trajan Inscription in Rome*, Catfish Press, Davenport, Iowa 1961.

*Degering, Hermann. *Lettering*, Ernst Wasmuth, Berlin 1929; and Ernest Benn, London 1965.

*Diringer, David. *The Alphabet*, Hutchinson, London, 3rd Edition 1968.

Fairbank, Alfred. *A Book of Scripts*, King Penguin 1949 (see also Faber edition, London 1975).

Hector, L. C. *The Handwriting of English Documents*, Edward Arnold, London 1958.

Hübner, Emil. *Exempla Scripturae Epigraphicae Latinae . . .*, Berlin 1885.

Lowe, E. A. *English Uncial*, Oxford University Press 1960. Also Chapter 3(iii) of *The Legacy of the Middle Ages*, Oxford 1926.

Millar, Eric G. *English Illuminated Manuscripts from the Xth to the XIIIth Century*, Paris/Brussels 1926.

Morison, Stanley. *Politics and Script*, Oxford University Press 1972.

Mosley, James. 'Trajan Revived' from *Alphabet*, Vol I (Ed. R. S. Hutch-
ings), James Moran Ltd. for Kynoch Press, Birmingham 1964.

New Palaeographical Society. *Facsimiles of Ancient Manuscripts*, London
1903–12; second series, London 1913–30.

Palaeographical Society. *Facsimiles of Ancient Manuscripts*, London
1873–83; second series, London 1884–94.

*Thompson, E. Maunde. *An Introduction to Greek and Latin Palaeography*,
Oxford 1912.

Renaissance and later

Bartram, Alan. *Tombstone/Street – Name/Fascia – Lettering in the British
Isles*, 3 Vols, Lund Humphries, London; Watson Guptill, New York
1978.

Bickham, George. *The Universal Penman* 1743. Dover facsimile, New
York 1941.

*Blunt, Wilfrid. *Sweet Roman Hand*. James Barrie, London 1952.

Fairbank, Alfred, and Wolpe, Berthold. *Renaissance Handwriting*, Faber
& Faber, London 1960.

*Ogg, Oscar (Ed.) *Three Classics of Italian Calligraphy*, Dover, New York
1953.

Modern applications

Craig, James. *Phototypesetting*, Watson Guptill, New York; Pitman,
London 1978.

Gourdie, Tom. *Improve Your Handwriting*, A & C Black, London 1975.

Harvey, Michael. *Lettering Design*, The Bodley Head, London 1975.

*Johnston, Edward. *Writing & Illuminating, & Lettering*, A & C Black,
London; Taplinger, New York 1977 (first published 1906).

Johnston, Edward (Ed. Heather Child). *Formal Penmanship*, Lund
Humphries, London 1971.

Russell, Pat. *Lettering for Embroidery*, Batsford, London 1971.

*Shahn, Ben. *Love and Joy about Letters*, Cory, Adams and Mackay,
London 1963.

Stone, Reynolds. *Engravings*, John Murray, London 1977.

Typography

Catalogue of Books Printed in the XVth Century now in the British Museum
I–X, Trustees of the British Museum, London 1908; lithographic
reprint 1963.

Dreyfus, John. 'William Morris: Typographer' from *William Morris and the Art of the Book*, Pierpont Morgan Library, New York 1976.

*Morison, Stanley, and Day, Kenneth. *The Typographic Book*, Ernest Benn, London 1963.

Proctor, Robert, and Dunn, George (Ed.) *The Type Facsimile Society, Specimen of Early Printing Types*, Oxford University Press 1900–09.

Sutton, James, and Bartrum, Alan. *An Atlas of Type Forms*, Lund Humphries, London 1968.

Turner Berry, W., Johnson, A. F., and Jasper, W. P. *The Encyclopaedia of Type Faces*, Blandford Press, London 1962.

*Updike, D. B. *Printing Types, Their History, Forms and Use*, Harvard University Press 1922 and 1937.

Alphabets

Beisner, Monika. *Monika Beisner's ABC*, Eel Pie Publishing, London 1979.

*Nesbitt, Alexander. *Decorative Alphabets and Initials*, Dover, New York 1959.

Spencer, Herbert and Forbes, Colin. *New Alphabets A to Z*, Lund Humphries, London 1973.

Strange, Edward F. *Alphabets*, George Bell, London 1895.

Glossary

Ampersand The sign for 'and' that is a monogrammatic treatment of the Latin *ET*: &. The word 'ampersand' is a contraction from the recitation of the alphabet at schools in the days when the sign followed Z: '. . . X, Y, Z and *per se* and.'

Arming press A press for hot-stamping coats of arms with gold foil into bookbinders' leather.

Ascenders Stems which rise above the main body of minuscule letters.

Axial hinge Point at which the axes of stems cross each other, such as near the top of A or the bottom of V.

Bas-relief Standing out slightly from the background.

Blackletter An angular 14th- to 15th-century European script, having closely spaced and heavy minuscule stems.

Blocking Impressing letters or other detail into soft material such as leather by means of an engraved block. (*See* ARMING PRESS.)

Block-making Photo-etching or hand-engraving for imprinting in two dimensions or impressing in three.

Book-hand Calligraphic style employed in manuscript books.

Bow The curved part of a letter, e.g. of B, D or P.

Calligraphy Beautiful writing with pen or brush. A calligrapher is one who writes beautifully, a professional transcriber of manuscripts.

Carolingian minuscules The reformed book-hand encouraged by Charlemagne in the late 8th century at Tours, and which has decisively influenced all other European penmanship since then.

'Civil service hand' A 19th- and early 20th-century handwriting descendant of the copperplate style.

Codex A manuscript made up of leaves bound with wooden boards (the word 'codex' derives from *caudex*, the Latin for tree trunk), as distinct from the ancient volume in scroll form (from the Latin *voluta*: a scroll).

Copperplate Letter-form engraved into copper (or steel) plates for intaglio printing, or the style of handwriting derived from this by penmen using long split-pointed pens at controlled pressures.

Copybooks Exemplars published by writing masters of the 16th and 17th centuries for those who wished to improve their handwriting.

Counterchange A mirror-like switch of values; that is, the balance of light areas with dark ones, shape for shape.

Cursive Running – said of handwriting where the pen scarcely leaves the writing surface so letters are joined.

Descenders Stems which fall below the main body of minuscule letters.

Die-sinker An engraver who excavates metal in such a way that impressions or castings from the finished die are in accurate relief. Seals are engraved by die-sinkers.

Electronic gridding The formation of letters and numerals electronically upon a gridded background.

Engraving Carving by hand or machine into metal, stone, wood or other material either as a permanent record or as a means of multiplying impressions.

Fleuron Decorative unit, often floral, for assembling into borders and fanciful arrangements.

Flourishing Pen strokes or engraved letter stems extended in an extravagant yet skilful manner for emphasis, decoration or simply to occupy space.

Fount A complete set of printers' type of one face and size.

Guide lines Lines ruled temporarily upon a surface for the guidance of the letter-cutter, engraver, scribe or signwriter.

Half-uncial (See UNCIAL.)

Illumination Lighting-up the pages of a book with gold and/or colour.

Incuse Below the surface; sunken.

Intaglio Method of printing in which the ink lies in incisions on the plate's surface.

Italic An elegant and slanted form of handwriting, perfected in Italy during the 15th century and widely adopted throughout Europe in the 16th.

Justification Vertical alignment of the right-hand edges of printed matter by means of space adjustment within and/or between the words.

Letterpress Printing method in which the raised surface of the type or blocks transfers the ink on to the paper.

Ligature Any thin stroke connecting two letters.

Lithography (See OFFSET LITHOGRAPHY.)

Majuscule Capital letter-form: A, B, C, etc.

Matrix The mould from which a letter is cast in metal for letterpress printing. In phototypesetting the matrix is the glass plate that contains the film fount negative.

Minuscule Letter-form evolved from capitals, usually smaller a, b, c, etc.

Monoline Letter-form having no changes of stress; that is, having the same weight and width of stems throughout the alphabet.

Moveable type The invention of Johann Gutenberg at Mainz in the 1440s by which cast metal letters may be assembled and inked for printing.

Offset lithography Method of printing from flat plates treated so that what is to be printed can be inked but the remaining area rejects ink. The inked image is transferred from the plate via a rubber 'blanket' to the paper surface.

Ogee A continuous double curve; a snake-like track or meander.

Photocomposition Phototypesetting: the arrangement of positive images of letters, numerals and punctuation, projected from negative founts on to film or photosensitive paper.

Photo-litho facsimile Reproduction by means of offset lithography.

Plate-making Engraving the surface of a metal plate, either by hand or by etched process, from which to obtain inked impressions.

Punch-cutting Cutting away the background of a letter of the alphabet at the end of a steel bar so that it may be hardened and punched into a copper mould or matrix from which to cast soft-metal type.

Ranging All of the same height.

Relief Projecting from a flat surface; the opposite of incuse.

Reverse (*n.*) The back of a coin or medal.

Reverse (*v.t.*) In printing, to drop type out of a background so that it assumes the colour of the paper.

Round-hand Penmanship of rounded strokes as distinct from angular ones.

Routing-machine A device which scoops out the background of metal or other surfaces so that letters and numerals remain in relief.

Rustic hand An early script in which the vertical stress of main stems is minimal, and that of horizontal members is given weight.

Sampler A dictionary of stitches – a testimonial of skill – including the alphabet, usually worked upon canvas. Samplers were in evidence from the 16th to the 19th century.

Sanserif A term signifying the absence of serifs.

Serifs Terminal sharpnesses added to some letter-forms in the completion of their stems.

Soutache Flat ornamental braidwork of wool or silk applied to cloth in decorative designs.

Stem A main member of a letter of the Roman alphabet.

Transfer-lettering Printed sheets of adhesive alphabets, the letters

of which may be positioned in sequence and pressed into place on paper or other surface.

Typeface The style or type of letter-form adopted for a fount of printers' alphabet.

Typography The art of printing, or the style or appearance of printed matter.

Uncial A book-hand of rounded capital letters originally used for the texts of manuscripts from the 5th to the 8th century in Europe. The half-uncial is a concurrent and less rigid variation of the uncial book-hand, for general use, in which ascenders and descenders evolved towards true minuscule style.

Upper and lower case Of the two cases of printers' type, the upper one contains the majuscule letters of the alphabet, and the lower one the minuscule characters.

Vellum Calfskin prepared for the scribe's use as pages of manuscript books.

Versals Letters drawn extra large by the scribe for headings and titles, or for initiating verses of the scriptures, usually in colour and, if sufficiently important, done in gold.

Woodcut Removal of the long grained wood to obtain a print by inking the retained surfaces; usually printed in black.

Wood-engraving Incisions on the end grain of wood, the inked face providing the background to a print in which uninked areas below the surface form the white details of the picture.

Index

Page numbers in *italic* refer to the illustrations.

Index